W E
S
C

HAWAIIAN ISLANDS

San Francisco
Los Angeles

MEXICO

O C E A N

Tropic of Capricorn

140° 130° 120° 110° 100° 90° 80°

30°

PORTS OF CALL

PRAISE FOR *THE BATTALION ARTIST*

———

"There are thousands of World War II stories. But very few of those who lived those stories had the motivation, the ability—the talent—that Nat Bellantoni had. His paintings, his sketches, the photographs, everything he saved and brought back, are perhaps the most complete visual record we have of one man's deployment with the Seabees in the South Pacific."

—William Hilderbrand, Captain (Ret.),
Civil Engineer Corps, US Navy, and President Emeritus,
CEC/Seabee Historical Foundation

"Janice Blake and Nancy Bellantoni have created a beautifully written and illustrated war epic honoring Natale Bellantoni as he chronicled his World War II service in the US Navy's Seabees. By producing this magnificent book, they have captured the essence of battle and expeditionary combat construction and collated many artifacts that are haunting and intensely personal to warfighters from any era. We are all enriched and made better by observing the intimate details of Seabee life in World War II through the eyes of this Seabee and artist."

—Edward "Sonny" Masso, Rear Admiral (Ret.),
US Navy, and Executive Director,
Naval Historical Foundation

"*The Battalion Artist* is a timely and compelling look at Navy life in the South Pacific island campaign through the eyes of a talented young artist who found himself part of the vaunted Navy Seabees, whose Construction Battalions built the bases and airfields across the Pacific on the way to Japan—often operating their heavy equipment with rifles in hand. Featuring high-quality reproductions and backed by insightful commentary, this book allows the reader to follow the course of the Pacific war with a very human perspective on both the routine operations and the heart-pounding stress of combat. It is an outstanding tribute to a member of the Greatest Generation."

—Todd Creekman, Captain (Ret.),
US Navy, and Executive Director Emeritus,
Naval Historical Foundation

"*The Battalion Artist* is a great adventure. A gifted young painter leaves his prestigious art school in Boston, and the girl who loves him, to join the Navy and go off to World War II. The belly of a ship carries him to far-off tropical islands in the South Pacific to fight the Japanese. The islands refresh his color palette and his senses. It's all here—the daring and heroism, the self-sacrifice, the fascination with distant corners of the planet that needed defending. History made personal, and one of the final unexpected sagas retrieved from World War II."

—Anthony Weller, author of *First into Nagasaki: The Censored Eyewitness Dispatches on Post-Atomic Japan and Its Prisoners of War* and *Weller's War: A Legendary Foreign Correspondent's Saga of World War II on Five Continents*

"The personal and intimate story of individual men brings the truth of war home. Watercolors, so vibrant with color and life they could still be wet, bring the beauty and agony of the war in the Pacific home. A fabulous book."

—Helen Simonson, author of *Major Pettigrew's Last Stand,*
The Summer Before the War

"Nat's paintings capture the loneliness of being away from home and also the need to find some quiet space on a ship with one thousand–plus other men. The pictures painted at sea were the ones that sparked my memory the most—reminders of long weeks with some spectacular sunrises and sunsets, and the contrast between hours of boredom and watches that were spiked by the adrenaline rush of general quarter alarms."

—Paul L. Smith, Commander (Ret.), US Navy

THE
BATTALION
ARTIST

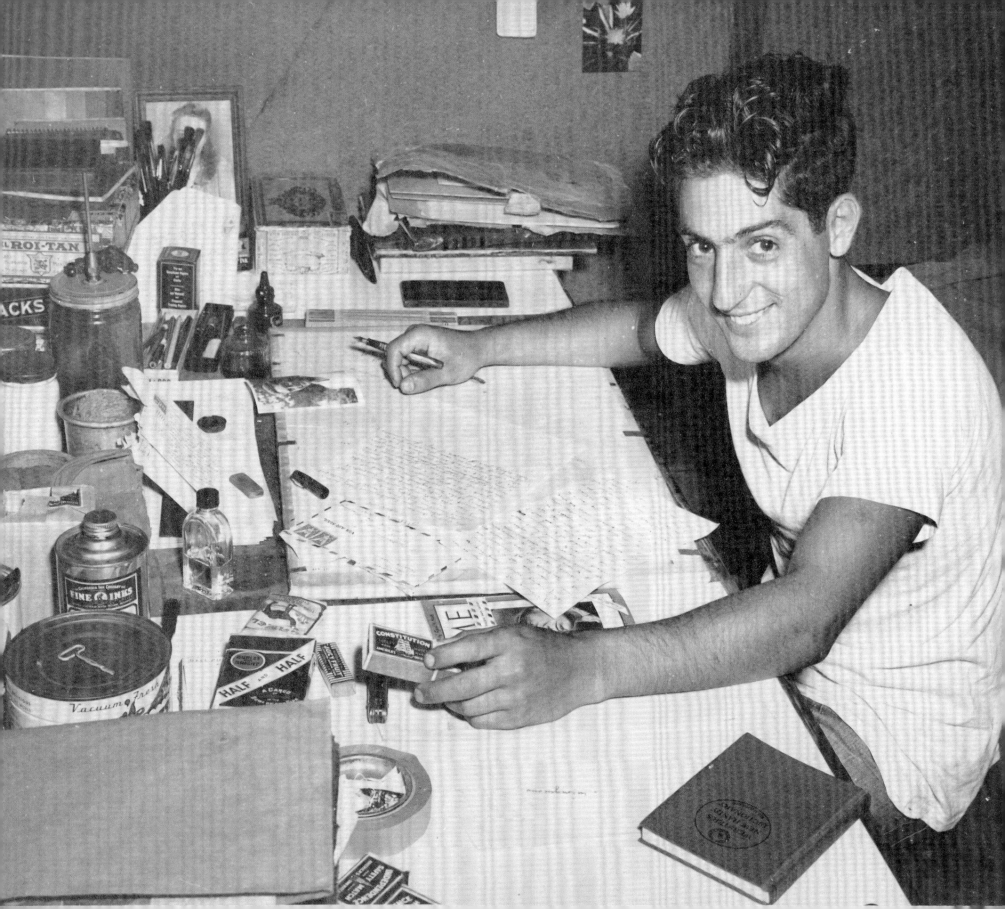

THE BATTALION ARTIST

A Navy Seabee's Sketchbook of War
in the South Pacific, 1943–1945

Written by

Janice Blake

Edited by

Nancy Bellantoni

Illustrated by

Nat Bellantoni

Foreword by

Jean M. Cannon

Note from the Director by

Eric Wakin

HOOVER INSTITUTION PRESS

Stanford University | Stanford, California

www.hoover.org

Hoover Institution Press Publication No. 696

Hoover Institution at Leland Stanford Junior University,
Stanford, California 94305-6003

First printing 2019
25 24 23 22 21 20 19 7 6 5 4 3 2 1

Cover design by Jennifer Navarrette

The paper used in this publication meets the minimum requirements of the American National Standard for Information Sciences—Permanence of Paper for Printed Library Materials, ANSI/NISO Z39.48-1992. ∞

Cataloging-in-Publication Data is available from the Library of Congress.
ISBN: 978-0-8179-2224-5 (cloth : alk. paper)
ISBN: 978-0-8179-2228-3 (PDF)

Design and layout by Howie Severson
Printed and bound by Friesens Corporation in Canada

CONTENTS

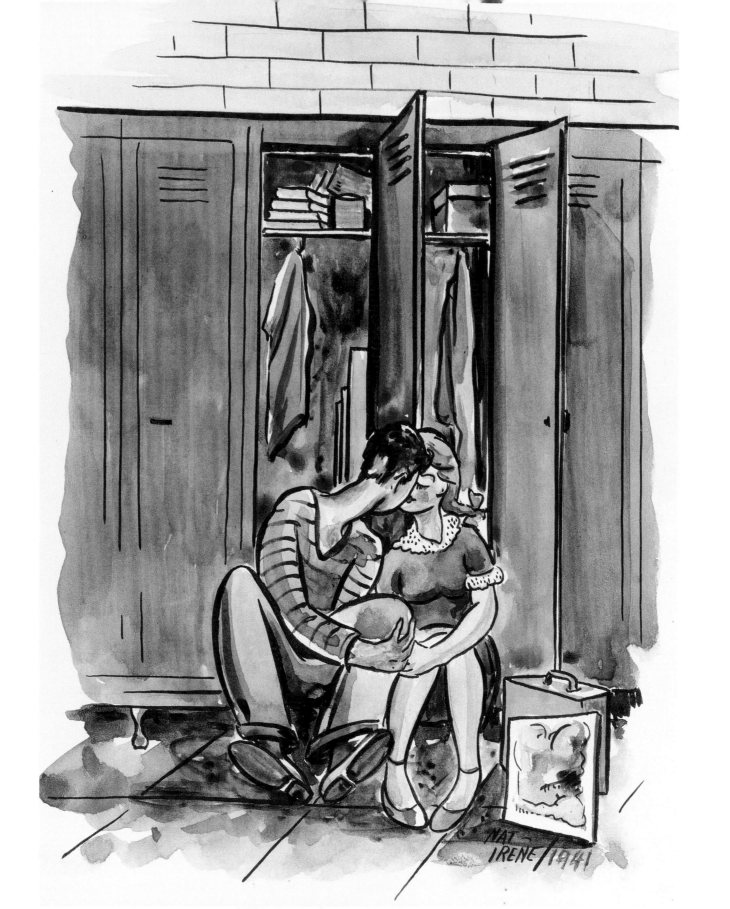

DEDICATED TO IRENE

. . . and to all the young women who were left behind,
waiting, worrying, hoping.

━━━━━━

This book is about a young man who went off to war. He traveled halfway around the world. He lived for months on islands that—until he landed on them—he had never heard of. He fought off fear, witnessed death, and suffered the miseries of relentless heat, perpetual humidity, drenching rains, persistent bugs, and tropical disease. But he also had the satisfaction—day in and day out—of knowing he was contributing to a mighty enterprise. He had adventures he would never forget, completed projects he was deeply proud of, and made friendships that would last a lifetime.

And yet this is also the story of a young woman. Irene Sztucinski completed college and got a job. The work she had trained for—fashion design—was simply not possible in a wartime economy. And so she designed store displays instead. She enjoyed her work, but it was not the career she had dreamed of. She lived with her parents, socialized with family and friends and waited. She waited. She worried. She hoped. She feared. She read the newspaper and listened to radio news cautiously. Every fragment of war reportage filled her with trepidation, because whatever happened this morning or yesterday or an hour ago was irrelevant. He might have been safe then, but what about now? This moment? If the worst happened, it would take days, or weeks, for word to reach her. Still, she rushed to the mailbox every day, because a letter from him made his presence real for her—for at least those moments in which she was reading. Some days there were letters, written weeks before, from somewhere in the Pacific. She never knew for certain. He was not allowed to tell her where he was. The return address was always 78th N.C.B. c/o F.P.O. San Fran, Calif.

The Battalion Artist explores three years, three months, and three days of Nat Bellantoni's long life. Irene is barely mentioned. She is offstage throughout. Yet in truth, she is present on every page. For without her love, her letters, her willingness to put her life on hold while he was away and to put her dreams on the shelf when he returned, his life story might have been quite different. The art he created in the South Pacific was, essentially, for her. And the making of it is what sustained his spirit.

Construction Workers...
BUILD AND FIGHT FOR VICTORY—
Join the **SEABEES**

JOHN FALTER USNR

Ask about new Volunteer Plan

APPLY TO YOUR NEAREST NAVY RECRUITING STATION
You may also volunteer for service with the Army Engineers. See your nearest Army Recruiting Station

FOREWORD

———

It is with great pleasure that the Hoover Library & Archives presents this volume dedicated to the life and artwork of Natale Bellantoni, Second World War artist of the 78th battalion of the US Navy "Seabees"—the tireless and ingenious construction battalions that were formed after the attack on Pearl Harbor and played a vital role in America's victory in the Pacific theater. The Natale Bellantoni collection, which includes watercolor paintings, sketchbooks, photographs, letters, and wartime ephemera, arrived at the Hoover Institution in 2017. It documents the personal experiences of not only one of the US Navy's most gifted artists but an entire generation of young American soldiers serving in the harrowing conditions of World War II.

Since its founding in 1919, the Hoover Library & Archives has collected, preserved, and made available the most important material on social, economic, and political change from the early twentieth century to the present day. The collection of Nat Bellantoni, bearing the perspective of a young Seabee and fine artist, broadens and deepens the Hoover Library & Archives' holdings on World War II, fleshing out both the individual experience and the logistics of fighting history's largest global conflict.

The Natale Bellantoni collection complements the Library & Archives' other significant holdings on World War II, including the diaries of General Joseph "Vinegar Joe" Stilwell, America's military commander in the Chinese, Burmese, and Indian theaters; the diaries of Generalissimo Chiang Kai-shek, leader of Nationalist China (our most requested item); the papers of Stanley Hornbeck, chief of the State Department's Division of Far Eastern Affairs; and materials related to the courageous Flying Tigers, aviators who risked their lives over and over again to fly one of the war's most dangerous supply lines over "The Hump," the eastern end of the Himalayan mountains.

With its focus on the experiences of construction battalions during World War II, the Bellantoni collection provides insight into a sector of American military service that is too

often overlooked. Historians argue—sometimes bitterly—about whether air power won World War II or whether naval power tipped the balance for the Allied nations. No matter which side of the argument you favor, one conclusion emerges: neither Flying Fortresses nor naval warships would have been able to fight without the airfields, docks, roads, supply lines, and basic human accommodations designed and built by Seabees.

The Second World War was history's greatest construction war, especially in the wake of Pearl Harbor, as the Allies quickly understood they could not win the war against Japan without many bases. The push toward Tokyo would require hopscotching from Pacific island to Pacific island. Movement could only be accomplished by connecting bases for housing fighters and ammunition, refueling airplanes, and repairing ships. Bases would be the key to victory. Before Pearl Harbor, the US Civil Engineer Corps was a small outfit. Almost all naval construction labor was conducted by private civilian contractors who lacked military training and could not be sent into combat. Thus, the first naval construction battalion was formed on December 28, 1941, and was soon nicknamed the "Seabees"—a name that was a jocular reinvention of the initials CB, standing for Construction Battalion.

Before war's end, more than 250,000 American men would serve as Seabees. Many of the first Seabees who volunteered had already helped accomplish America's largest construction and engineering feats. These were the men who had built the Hoover Dam, tunneled under New York's East River, spun steel across the Golden Gate Bridge, and laid the stones that built the Blue Ridge Parkway. Few of these men were subject to the draft; of the first 100,000 volunteers for the Seabees, the average age was 31. Many of the Seabees had families and would have received draft deferments (and inflated wages) as the most skilled workers in stateside factories or shipyards. Yet men like Nat Bellantoni rushed to join the new construction battalions and to serve their country by employing their honed skills under constant threat of danger and death. For Bellantoni, at age twenty-one a gifted art student from Massachusetts, the Seabees offered an opportunity to use his skills in drafting, sketching, architecture, and photography. When not employing his skills in an official capacity, he created the dozens of watercolor paintings featured in this volume, which capture beautifully the landscapes and conditions of Seabees serving in the Pacific theater.

Through paintings, sketches, and photographs, Bellantoni documented the spirit and determination of the newly formed Seabees. Almost as soon as the push across the Pacific began, the new construction battalions gained a reputation for engineering ingenuity and pluck. The first Seabee unit sent overseas, nicknamed "The Bobcats," struggled against unimaginable conditions to build a fueling station at Bora Bora, in the Society Islands of the South Pacific. Following Bora Bora, the Seabees' baptism by fire came at Guadalcanal. Upon their arrival on the island, Marines at first made fun of the "old men" ("Say, pop, didn't you get your wars mixed up?") and the fact that the newly formed Seabee battalions lacked organization and established service traditions (not "construction battalions" but "confused bastards," joked the young Marines). The unfolding events on Guadalcanal—and particularly the building of Henderson Air Field under heavy fire—soon redirected the Marines' attitude from drollery to reverence. The newest battalions, thrown in beside the oldest and proudest, soon proved they could organize and execute

the seemingly impossible engineering feats that allowed the Marines to continue their battle across the Pacific and into enemy territory. Not only did the Seabees rehabilitate Henderson Field from a mud pit to a first-class airfield (the Japanese, who built the runway originally, had hacked it crudely out of the jungle without asphalt or drainage), they built docks to unload supplies from ships, cut millions of feet of lumber to build barracks and warehouses, drained swamps in order to fight off mosquitoes and malaria, and constructed hundreds of miles of roads on the island.

The feat of establishing a base at Guadalcanal required organization, teamwork, and speed. Under heavy enemy fire, the construction battalions coordinated so efficiently that one hundred Seabees could repair the damage of a five hundred-pound bomb strike on an airstrip in forty minutes, completely flummoxing Japanese bombers and no doubt damaging the enemy's confidence in its air power. After quickly and skillfully building the machinery necessary to maintain the base at Guadalcanal, Seabees could be heard sportingly reporting to their Marine chums that the construction battalions had been sent "to protect these helpless Marines." Inter-service heckling continued after Guadalcanal, but with grudging respect on both sides. The Marines and Army may have driven the Japanese off the island, but it was the Seabees who ensured that Americans could stay and prosper on Guadalcanal, supplying everything from ammunition magazines to a "Tojo Ice Company" that provided cool drinks to soldiers in the jungle heat. Before the invasion of Guadalcanal, Marines, who always pride themselves on being first to the fight, joked that when Army and Navy servicemen get to heaven they find Marines patrolling the streets. After Guadalcanal, Seabees informed Marines

that when they get to heaven they will find that Seabees had *built* the streets. By war's end, the Seabees had designed a jocular "Junior Seabee" badge that was given to any leatherneck who served with a Seabee battalion for three months or more.

After the incredible achievement of establishing a structurally sound runway and base at Guadalcanal, the Seabees continued across the Pacific. As documented in Natale Bellantoni's collection, the Seabees traveled to New Caledonia, the Admiralty Islands, and Okinawa. At the famous hoisting of the American flag on Mount Suribachi, Marines used a flagpole hastily fashioned by an ingenious Seabee. Without the Seabees' engineering and ingenuity, plus the moxie and persistence that came to be celebrated in their well-known "Can Do!" motto, Allied success in the Pacific simply would not have been possible.

The material featured in this volume stands as a testament to the many hardships and uncertainties Seabees faced during their contributions to ultimate victory in the Pacific. They suffered long weeks at sea headed toward unknown destinations (Bellantoni painted many scenes en route to what his battalion called "Island X"), hostile climates, bombardment, and exposure to dangerous diseases. They also, as captured in Bellantoni's paintings, drawings, and letters, achieved incredible camaraderie, saw landscapes and wildlife they had only read about in books, and met Pacific islanders who were to them exotic and fascinating. As Nancy Bellantoni and Janice Blake emphasize in this volume, Nat Bellantoni's wartime months at sea and on Pacific islands served as one of the most creative and compelling episodes in the artist's long and artistically prolific life. Showcasing Nat Bellantoni's beautiful and meticulous

renderings of the Seabee experience, this book also sheds new light on a too-often overshadowed group of American soldiers who faced and conquered hostile terrain, limited resources, disease and discomfort, and the constant threat of enemy fire as they built, dug, crawled, bulldozed, and hammered their way from San Francisco to Tokyo.

In this volume readers will find an image of the Seabees' official insignia, designed by Carpenter's Mate First Class Frank Lafrate in 1942, which features a fighting bee wearing a sailor's hat and bearing a hammer, wrench, and tommy gun. The rendering stands tribute to the Seabees' ingenuity, originality, dedication to hard work, and humor.

A wartime journalist once sportingly claimed that the Seabees "can build tank traps with sticks of macaroni, repair a lady's wrist watch with a Stilson wrench, or pitch hay with a one-prong fork." But perhaps General MacArthur summed up the wartime contributions of the construction battalions best when, in 1944, he told Ben Moreell, the wartime chief of the Civil Engineer Corps (also known as "the King Bee"), that "the only trouble with your Seabees is that I do not have enough of them."

The Natale Bellantoni collection deepens our understanding of the courageous engineers, welders, stevedores, mechanics, riveters, architects, and artists who made Allied victory in the Pacific possible. We are grateful that it has found its home at the Hoover Library & Archives. The collection will be preserved for future generations of scholars, readers, and visitors to the archives who no doubt will benefit from this unique set of materials and the fascinating history it represents.

Jean M. Cannon
Curator for North American Collections
Hoover Library & Archives, Stanford University

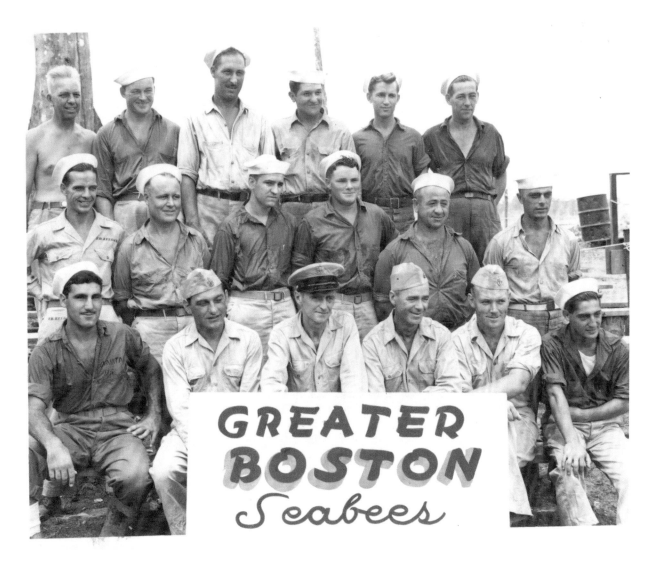

Natale Bellantoni, seated at the far right on the first row, poses for a photograph with fellow Seabees from Boston behind a sign he hand-lettered for the occasion. During World War II Seabees were indispensable to Allied success: they built an archipelago of bases in the Pacific Theater and were among the first soldiers ashore on D-Day, tasked with the dangerous assignment of carrying out the demolition of Germany's fortifications on the Atlantic Wall under heavy fire. Following the Second World War, Seabee veterans such as Bellantoni watched subsequent units participate in conflicts such as the Vietnam War and the War in Iraq, as well as myriad humanitarian aid missions.

A NOTE FROM THE DIRECTOR

The Hoover Institution Library & Archives, a repository dedicated to the study and understanding of wars, revolutions, and peace movements of the past hundred years, is an international hub of scholarly research on World War II, with significant collections dedicated to the experiences of soldiers in the Pacific Theater. The Natale Bellantoni collection, with its stunning and accomplished artwork, photographs, correspondence, and memorabilia, serves as perhaps our richest collection to date documenting the reality that US naval construction battalions faced as they fought disease, harsh climates, and armed enemies to build airfields, docks, and barracks for the millions of American fighters crossing the Pacific Ocean during the Second World War, headed to Japan. We thank the Bellantoni family for entrusting this rich resource to the Hoover Institution, so that we may preserve it for future generations to learn of the hardships Navy Seabees endured to preserve our American way of life. We also thank Janice Blake and Nancy Bellantoni for providing us with a text that tells the nuanced human story of Natale—"Nat"—Bellantoni, creator of the beautiful watercolors and sketches found in *The Battalion Artist*. The volume allows us to better understand the artist, his generation, and the incredible circumstances they faced at one of history's most pivotal moments.

In addition to telling the personal story of a gifted painter, *The Battalion Artist* also speaks to the proud legacy of the Seabees themselves, one of the most tough, ingenious, and indefatigable branches of the American military forces. Born out of the necessity of fighting in the Pacific after Pearl Harbor, naval construction battalions made their mark— "Can Do!" goes the motto—by building bases under heavy fire and horrid conditions, showing nearly superhuman endurance. The tradition continues. Following their courageous service in the dangerous waters of the Pacific during World War II, Seabees served in Korea, Vietnam, the Gulf War, and in all American conflicts since 9/11. Over 11,000 men and women currently serve in the US construction battalions that support the American

armed forces, building the facilities that house soldiers and supplies and also providing disaster relief and humanitarian aid. The Seabees helped solve the flooding crisis in the days after Hurricane Katrina; provided food and shelter for victims of the Indian Ocean tsunami; built roads and drilled wells for Iraqi Kurdish refugees after the Gulf War; and have constructed medical facilities, schools, and orphanages in remote areas of Africa and Asia.

During World War II many Americans became enamored of the lionhearted naval construction battalions through the romantic film *The Fighting Seabees* (1944), starring John Wayne as Wedge Donovan, a tough-talking construction boss recruited into the Seabees during their infancy. Aside from showcasing scenes of The Duke fighting the Japanese enemy by rigging explosives onto a bulldozer, the movie also popularized "The Song of the Seabees" and its lyrics "we can build and we can fight/we'll pave the way to victory/and guard it day and night." Perhaps just as significant is a line of dialogue delivered by Seabee Lieutenant Commander Robert Yarrow (Dennis O'Keefe) at the film's end: "We build for the fighters, and we fight for what we build."

We are proud to honor Natale Bellantoni and his fellow servicemen who—from World War II to present day—have fought courageously and unflinchingly to defend their country and the human freedom it represents. What they have built and continue to build is a gift to us all.

Eric Wakin
Deputy Director
Research Fellow
Robert H. Malott Director of Library & Archives
Hoover Institution, Stanford University

PREFACE

═══════

When a young man packs his seabag and takes leave of his family and his sweetheart to go to war, he realizes he is preparing for unknown dangers and life-altering experiences. He knows, yet never admits he knows, that he may not be coming back.

What does he choose to take with him?

For Nat Bellantoni, the answer was obvious. The way he knew best to manage the narrative of his life and to cope with the ups and downs of his feelings was to create images—visual records that spoke of what he felt, as well as what he saw. Sketching, drawing, painting—these were the best ways Nat knew to share his observations, ideas, and emotions with the people he cared about. More important, the quiet work of transforming ideas into images transported him to a realm of inner peace.

And so, as he packed, Nat tucked in among the skivvies and the crisp new uniforms a clutch of small spiral-bound sketchbooks, a tablet of art paper, a supply of artist's pencils, and a box of watercolors. With these—in addition to whatever he was called upon to do by the Navy—he would fight the war on his own terms.

THE ART STUDENT

Nat Bellantoni had known since childhood that he wanted to be—that he in fact was—an artist. For as long as he could remember, Nat's driving desire was to learn all he could about the materials and techniques that would enable him to express himself eloquently with visuals rather than words. The Bellantoni family was filled with artists. Nat's parents recognized early on their son's aptitude for drawing, his love of painting, his irrepressible creativity. And so they made sure he always had art lessons, even though such extras often stretched their modest Depression-era budget. How could they *not* provide such lessons? It was clear that Nat's passion for artistic expression was the essence of who he was.

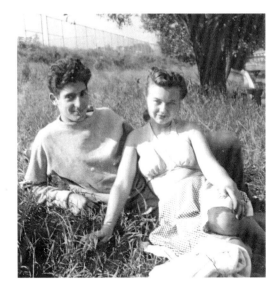

A backdrop of worldwide strife

Nat graduated from English High School, one of Boston's renowned exam schools, in June 1939. His senior year had unfolded against a frightening backdrop of worldwide strife. Events in Europe, though still distant, cast a worrisome shadow on the consciousness of America's youth. Like just about everyone else across the country at that time, Nat pushed the troubling news from Europe—and Asia, too—to the back of his mind. The world situation was not something he could do anything about. Besides, as summer turned into fall, his focus was far closer to home.

In early September, Nat walked through the doors of the Massachusetts School of Art (Mass Art) in Boston's Fenway neighborhood. He could barely contain his excitement. Some of the most respected artists of the day were teaching at Mass Art. Nat was smitten—by the energy of so much creative talent, the heady smell of oil paints, the responsive pliancy of modeling clay, the immediacy of life drawing class. Nat signed up for courses in color theory and composition, art history and printmaking. Each day he believed he was exactly where he belonged, doing exactly what he was meant to be doing.

For more than two years, as relentlessly and single-mindedly as the Nazis strove to dominate Europe and the Japanese subjugated their neighbors in China, Nat pursued his goal of becoming an accomplished artist. He was aware of the warfare overseas, of course. But all that terrible fighting still seemed very far away.

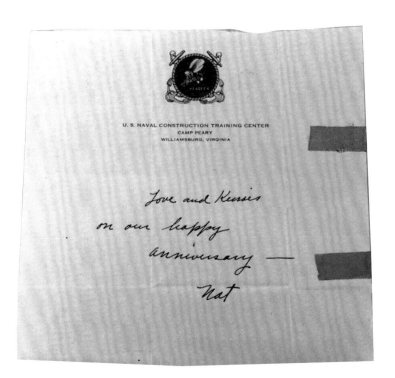

U. S. NAVAL CONSTRUCTION TRAINING CENTER
CAMP PEARY
WILLIAMSBURG, VIRGINIA

Love and Kisses

on our happy

anniversary —

Nat

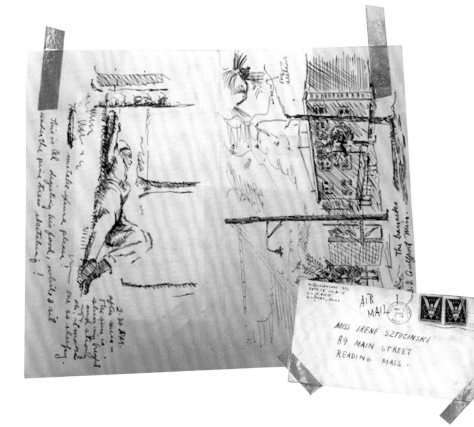

2:30 A.M.

MISS IRENE SZTUCINSKI
89 MAIN STREET
READING MASS.

AIR MAIL

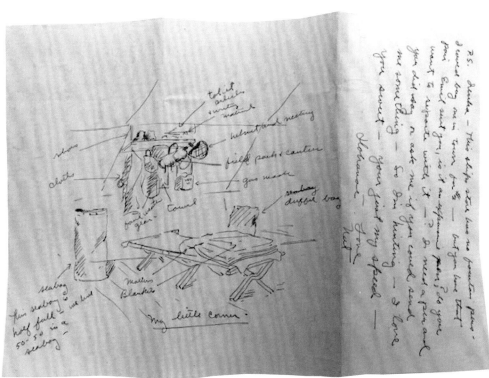

toilet articles
housed

helmet and netting

field pack & canteen

gas mask

rifle

shoes

clothes

seabag
duffle bag

Mattress
Blanket

cot

My little corner.

P.S.

your girl my speed —
Love
Nat

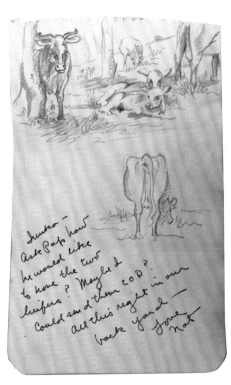

Irene —
Ask Papa how
he would like
to have the two
heifers? Maybe I
could send them C.O.D.?
All this right in our
back yard —
Love Nat

FROM ART STUDENT TO SEABEE

The dilemma that faced an entire generation

December 7, 1941. The stunning news that Pearl Harbor had been bombed, and the country was suddenly at war, changed everything for the students at Mass Art and in fact for college students across America. By the time Nat, then a junior, returned from Christmas break, the talk among his classmates was all about the war—what was going to happen next, who had already joined up, which service was best, and why choose one over the other. For months, Nat struggled to make a decision, torn equally between two compelling options—sign up, take a stand against the forces of evil, defend his beloved home and family; or finish school first.

All the while, his sketchbooks were an ever-present part of Nat's life. He sketched, drew, and painted the way other people might keep a diary. This was Nat's way of clarifying his thoughts. Still, the question he thought about most remained unanswered.

Not to decide would be to decide

Nat returned to Mass Art in fall 1942, planning to finish school and then figure out what to do about the war. But the shadow of the Selective Service was looming large. He was twenty-one. More and more young men his age were being called up. Every day he wondered, as he headed home on the

February 9, 1943
78th Battalion commissioned
at Camp Peary, VA

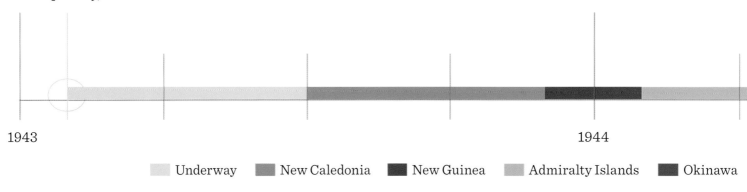

1943

1944

Underway New Caledonia New Guinea Admiralty Islands Okinawa

trolley, whether the dreaded notice would be sitting on the kitchen table. Nat knew that if he didn't make a choice and enlist, the draft board would decide for him. He had read about the Seabees, the US Naval Construction Battalions. He liked the idea that with them he could put his skills to work—help win the war by building rather than killing. Nat decided to set aside his goals. He would leave art school behind. He would also leave behind Irene Sztucinski, the beautiful, funny, and delightfully inventive young woman he had met in one of his classes. He and Irene had felt the spark of mutual attraction almost instantly; they had begun dating soon after school started, and they had fallen in love. But Irene—like his career as a professional artist—would have to wait.

New home, new family—for the duration

On October 7, 1942, Natale Thomas Bellantoni of Boston, Massachusetts, presented himself at the local naval recruiting office and signed on for the duration. He was given the service number 2033300 and assigned to the 78th Construction Battalion. His official Navy rate was carpenter's mate, a catchall for many Seabees who had specialized skills. Ultimately, he would become the battalion artist—a designation that seemed odd in the midst of war. But like all other Seabees, his training and skills would be put to good use. After boot camp, he would be sent to camouflage school. For the next three years, three months, and

three days, the US Navy would be his home. And the men of the 78th Construction Battalion would be his family.

This book covers Nat's entire tour of duty overseas, from the time his unit left the familiar safe haven of the California coast to the day he was handed his Notice of Separation from the US Naval Service back in Boston. During that time he traveled across countless miles of ocean on ships ever vulnerable to attack, landed on beaches that had shortly before been in enemy hands, and lived and worked in areas where battles raged nearby and where air raid alerts were a constant reminder of imminent danger.

In an odd quirk of fate, Nat and photographer Ed Keegan were first-hand witnesses to the war's official end, or at least its prelude. They were sent to the tiny island of Ie Shima, just west of Okinawa, to record for the 78th Battalion's newsletter and log the August 19 landing of the Japanese delegation that would surrender in Manila.

Like thousands of others, Nat faced down fear, witnessed horrors, endured homesickness and hardship, and carried on without complaint. He came back home proudly—burdened with memories he would rather forget, treasuring friendships that would last a lifetime, and determined to rebuild the life he had left behind to serve his country.

September 29, 1945
78th Battalion
deactivated

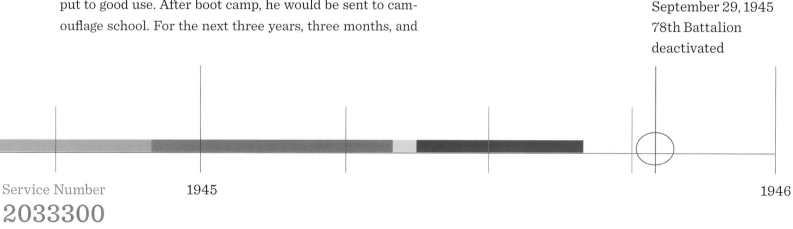

Service Number
2033300

1945

1946

I'm glad for this letter, it's much happier to receive letters than V-mails — even if I haven't said much You understand how hard it is to write when your restricted, otherwise I could say ~~much I~~

I told you ship life is OK, we have a room for our Bn. Log work & just about all the captions and articles are finished — now all that's missing is the "interesting future." Ed & Al are all OK, getting rusty faces from the sun and were all spending most of our time reading & talking about things in general — namely our love ones!!

Sometimes when I ~~stand~~ "forward" & watch the sunset I can almost feel you besides me, breathing deeply and lovely — I pray for a soon return to you — for I love you endlessly & wive been away much to long — the love we give to each other will be great for it!! Regards to everyone — I think of them also — Ever yours Nat

INTRODUCTION

W hen I was a little girl, there were four watercolor paintings above a green couch, which sat on an oriental rug in the living room of our house in the suburbs of Boston. My family didn't talk about the paintings much; they were just there—four colorful, small, rectangular objects on the wall. The subject matter was exotic for 1950s America: palm trees, thatched structures, skeletons of Quonset huts being erected, military airplanes and ships, native islanders and enlisted men working side by side. I remember sitting on that couch reading storybooks. Little did I realize the power of the stories in the images just above my head, nor the proximity to history in which I was living.

My father, Nat Bellantoni, left Massachusetts College of Art in the fall of 1942, joined the Navy, and eight months later found himself on a tiny South Pacific island in the midst of a ferocious war with no foreseeable ending. Constantly vulnerable to enemy attack, living and working in a bizarre and unfamiliar jungle environment, and perpetually longing for home and his future wife, Irene, he turned to the coping mechanism he knew best. He created a visual diary.

The Battalion Artist chronicles the wartime experiences of just one man. And yet it reflects the story of an entire generation. More than 16 million men and women served in the US military; 350,000 of them, like Nat, were Navy Seabees. I had the honor of meeting some of them as I accompanied my father, then in his eighties, to reunions of the 78th Construction Battalion in various states. These generous, strong men were proud of their service to their country and to the world. This book is my father's tribute to them and to all that they accomplished.

In his role as the battalion artist, my father worked closely with the battalion's photographer and writers to create the *Battalion Log, 78th Naval Construction Battalion*, as well as the daily newspaper, *Tractor Tales*. A compulsive archivist, he kept at least one

copy of every photograph snapped by Edwin Keegan, some of his own paste-ups for the *Battalion Log*, a raft of Navy documents, handouts, and mementos—both official and unofficial—as well as gifts from native islanders and even seashells. Seventy-five years later, when Janice Blake and I began to plan how we would create this book, we had twenty of his paintings, several sketchbooks, his letters to Irene, over seven hundred photographs, and other treasures from the 1940s South Pacific that he had saved in boxes. Sitting in my living room surrounded by all this, Janice and I realized that our objective was not just to write about Nat's paintings, but to insert all these priceless items into the timeline of history.

It is a rare thing to experience authentic World War II images in full color. Nat's paintings allow us to see and feel the colors and textures of his wartime life through the prism of a curious and creative young man. He painted what he saw—it was his passion, not his job. His subject matter was his daily life: endless weeks at sea, harbors and ships, men at work, airstrips, the local countryside, and the view of enemy planes overhead at night from his foxhole.

As a child, I carefully studied the four paintings, memorizing the brush strokes, the colors, and the compositions. I knew they were from "the War." I also knew bits and pieces of stories, like the one about the tribal chieftain who wanted Nat to marry his daughter and gave him a string of dog's teeth as a preview of the valuable dowry he would provide. My mother wore that keepsake as a necklace on special occasions. But mostly, there was no true context for these paintings in my suburban life. I realize now, in retrospect, that for my parents the paintings over the couch were symbols of the life-changing experiences the two of them had shared, despite the fact that they did so from opposite sides of the world—a perennial and subtle reminder of difficult times and of my parents' very personal contribution to the triumph of American democracy.

Nancy Bellantoni, Boston

February 9, 1943
78th Battalion
commissioned at
Camp Peary, VA

June 16, 1943
Depart Port Hueneme, CA
aboard the MS Day Star

During this voyage Nat painted

SIGNAL FLAGS

SCANNING
THE HORIZON

GUN WATCH

KP

July 13, 1943
Arrive Nouméa,
New Caledonia

1943

1

UNDERWAY:
ABOARD THE MS *DAY STAR*

===

June 16, 1943. The MS *Day Star*, with the US Navy's 78th Construction Battalion aboard (more than one thousand men), slipped away from the dock at Port Hueneme, California, headed for the open waters of the wide Pacific. The battalion band struck up the brave chords of *Anchors Aweigh*. It had taken all morning for the men to board the ship, each one lugging his field pack and weapon, trench shovel and machete, plus the gear and tools that would be essential to his work. The men had been through weeks of rigorous boot camp in Virginia, then more weeks and months of advanced training in Rhode Island, Mississippi, and, finally, at Port Hueneme— the Navy's Seabee base up the coast from Los Angeles.

FUTURE UNKNOWN: ISLAND X

Spread over thousands of miles of open ocean were countless well-fortified islands still in enemy hands. Many of these would have to be taken before the Allies could begin a final assault on the Japanese homeland. The members of the 78th would be building bases so that American troops could move forward. That, they knew. But where exactly? That, they did not know. On this cruise, and every time hereafter that they boarded a ship for a new assignment, the most they would be told for certain was that they were headed for Island X.

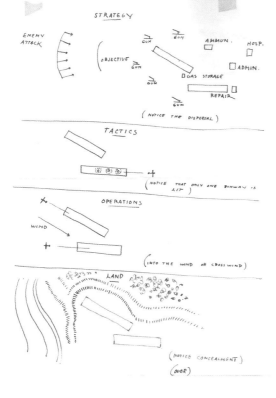

FIGHTING FEAR

Like every sailor, soldier, and Marine, Nat grasped at any scraps of news, rumor, or speculation about the war's progress that came his way. Aboard ship, the news was slow in coming and often incomplete. And there was too much time for thinking.

Alone in his bunk at night, as the engine droned and the hull occasionally creaked, Nat often thought back to those frightening first weeks of the war, to the newspaper headlines and urgent, grim voices on the radio: Pearl Harbor. Luzon. Corregidor. Bataan. Nat recalled how his father sometimes shook the morning paper while he was reading, as though to catapult the bad news right off the page.

After months that brought only shock, anxiety, and grief, the tide began to turn. There was the Doolittle Raid on Tokyo, the Battle of the Coral Sea, and then Midway—heralded as Japan's first decisive military defeat in over a century. Nat remembered how his mother had stood up and

cocked her ear toward the radio when this good news came. A slight smile supplanted the look of worry that seemed to have given her a perpetually furrowed brow.

But now, nearly a year after Midway, the Japanese still controlled the vast oil reserves and rubber plantations of the East Indies and Southeast Asia. They were firmly entrenched in northern New Guinea. True, the US Marines had long since pushed them off Guadalcanal in the Solomons, but it had taken seven months of gruesome struggle. And the Japanese still held dozens of strategically vital islands across the Pacific.

The Seabee motto was "Can Do!" And always, before finally falling asleep, Nat would think about what he would be asked to do . . . could do . . . would do. And by visualizing action, he pushed back fear.

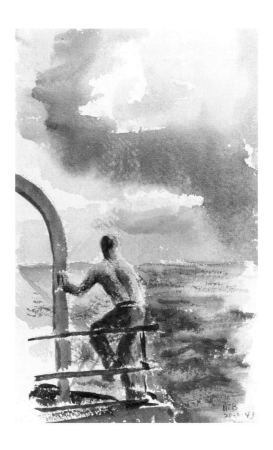

SIGNAL FLAGS

When the *Day Star* embarked, Nat, like every other man on board, knew that there was no guarantee he would return. Yet he refused to be afraid. He had already made a decision. He would try not to think about the danger and uncertainty of where he was and what he was doing. Instead, he would concentrate on the images he would bring back to Irene.

The two of them had talked all this over. They would both write, of course. And they would use their creativity and their artistry to stay connected, embellishing their correspondence with sketches, enclosing photos and mementos if they could. His paintings would reflect what he had seen and felt and thought but couldn't express as strongly with mere words.

Nat's watercolors and tablet of art paper were in his seabag. He would begin with the image that for him captured the essence of this dramatic moment: the brilliant colors of the signal flags that fluttered above the deck—blue against white, red against yellow, jumbles and cascades of red, blue, and yellow, all mixed together. These spoke, somehow, to the mixed feelings he knew he shared with every man on board. Home. Family. Friends. Sweethearts. All must be left behind. There was no way of knowing what the months ahead would be like. But this war had to be won, and what they were doing was truly right. These were among the multicolored thoughts that flew in their hearts as vividly as the flags that fluttered above the deck.

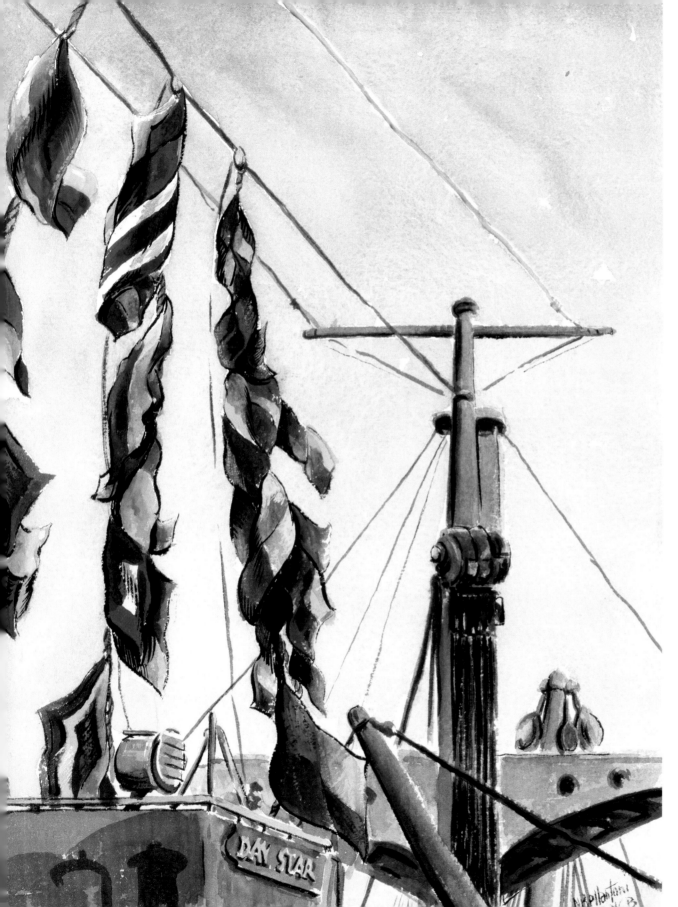

Signal flags, painted aboard
the MS *Day Star*, 1943.

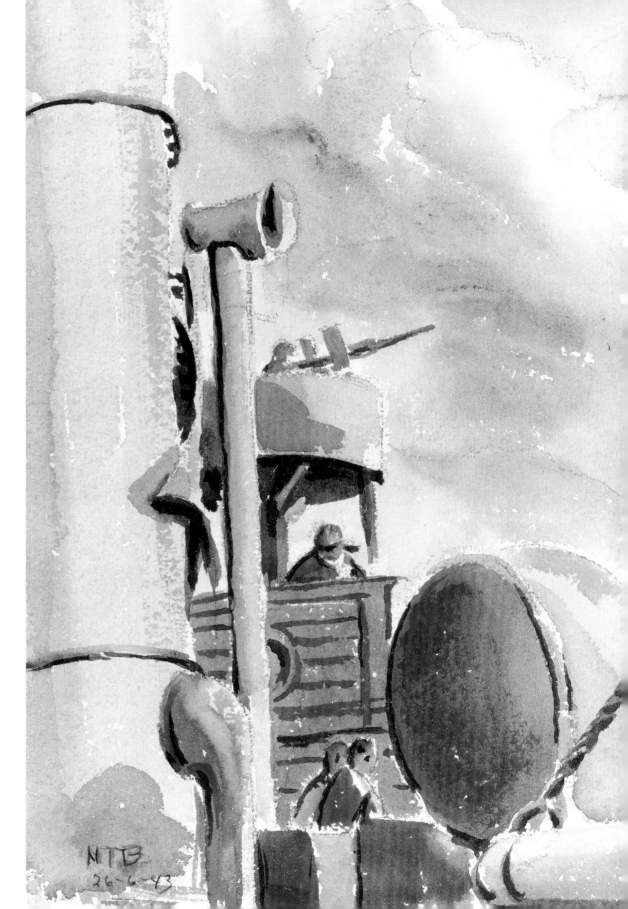

Scanning the horizon, painted
aboard the MS *Day Star*, 1943.

SCANNING THE HORIZON

The vast Pacific Ocean covers more than 60 million square miles, more than a third of the Earth's surface. The distance between Port Hueneme and the *Day Star*'s destination—the island of New Caledonia off the coast of Australia—was more than 6,200 miles. The men of the 78th Battalion would be at sea four weeks. But Nat, like his buddies, was unaware of these statistics. They did not yet know where they were headed or how long their voyage would be. They would find out where they were going when they got there.

For now, what Nat and the rest of the Seabees did know was that they were jammed together in crowded quarters, that the days were long and the routines were fast becoming tiresome. They slept in bunks stacked four high and ate taking turns in the mess because there weren't enough seats for all of them to sit down at the same time. The *Day Star* was a Danish ship, captured from the Germans and refitted as a troop transport. The Danish crewmen had stayed with their vessel and now crisscrossed the wide Pacific endlessly, bringing to its far reaches the men who were freedom's last, best hope to turn back the Japanese tide of brutality and aggression—sailors, Marines, soldiers, and these Seabees.

As the ship cruised westward, the only thing the men knew for certain was uncertainty. They were sailors aboard a ship and so were vulnerable to surprise attacks at any time, from bombers in the air or submarines under the sea. Their first challenge, then, was to stay alive. And so, around the clock each man took his turn at lookout.

Endlessly scanning the horizon for enemy craft was a tedious assignment. Nat strove to recreate on paper the heavy, dark intensity he felt when it was his turn to be on watch. Time seemed to stand still. Any change in the look of things—even the warm glow of the sky at sunup and sundown—felt ominous. Certainly, taking a moment to enjoy the beauty of the dawn would be wrong. Any letup in concentration was not an option, for even a moment's distraction could cause disaster. Each man knew that when he was on watch, his shipmates were counting on him, and him alone.

GUN WATCH

Although nobody ever spoke of it, the men aboard the *Day Star* well knew that the very water on which they sailed had absorbed and dispersed the blood of untold numbers of their comrades in arms. When the light cruiser USS *Juneau* was sunk off Guadalcanal back in November 1942, 687 men were lost, including five brothers—the Sullivans. In March 1943, while the 78th was still training in Gulfport, Mississippi, American and Australian planes had attacked a Japanese convoy headed for New Guinea with troops and supplies. Eight troop transports and four destroyers were sunk; more than three thousand enemy soldiers and sailors were killed. Of the 150 fighter planes escorting the convoy, 102 were shot down.

This stunning Japanese defeat would be remembered as the Battle of the Bismarck Sea. With it, the blood of the enemy also poured into the waters of the Pacific. In April, US code breakers had discovered the whereabouts of Admiral Isoroku Yamamoto, mastermind of the Pearl Harbor attack; P-38 fighters succeeded in shooting down his plane. So now, the blood of Yamamoto himself had been spilled in this vast ocean.

Nat thought about the nature of the enemy most often when he was on gun watch, and he knew it was the same for his buddies. Gun watch somehow felt even weightier than lookout duty. Scouring the horizon with binoculars was a huge responsibility, true. But if the lookout did spy an attacker, the men on gun watch knew that in that first instant of encounter, they were all that stood between the ship (and their shipmates) and utter destruction.

The antiaircraft gun, poised for action, was always echoed in the stance of the men beside it: alert, decisive, and ready. From the deck below, Nat was impressed with how this scene—awash in blues, grays, and greens that blended with sea and sky—was somehow reassuring. With those two men standing firm in the solid geometric mass of the turret, it seemed that every element of the ship was calm, confident, and capable, that even the taut cables and sturdy life rafts would spring into action almost of their own volition in support of these two men: two men who, for this four-hour watch, held all lives aboard in their hands.

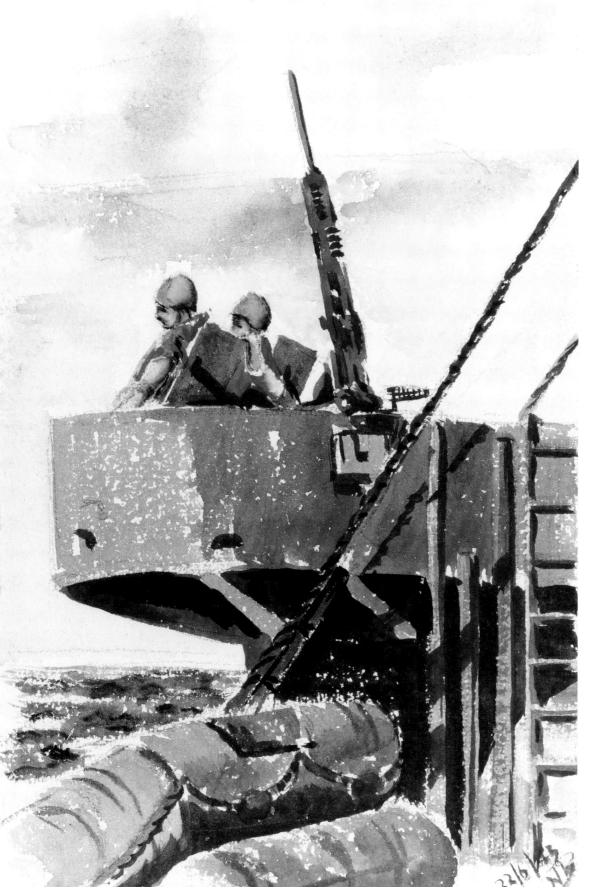

Gun watch, painted aboard
the MS *Day Star*, 1943.

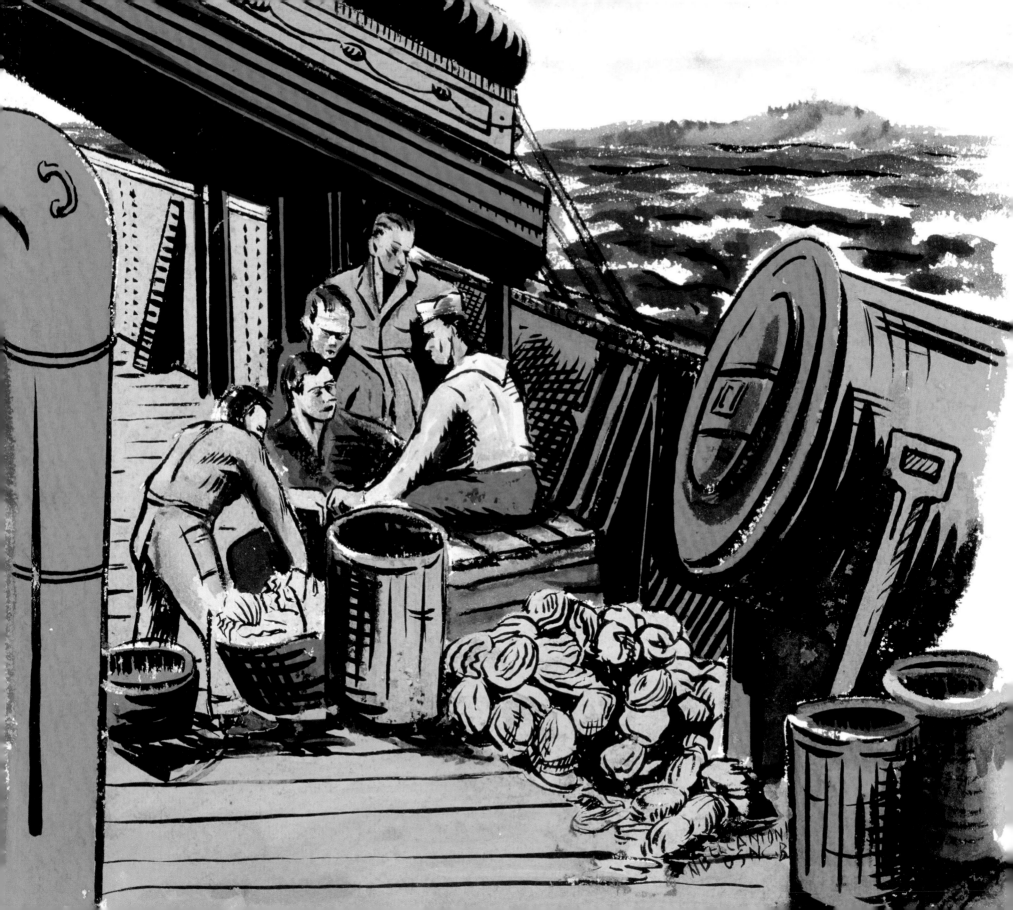

KP

At sea, the biggest challenge for all the men was to keep worrisome thoughts at bay. So when Nat was off-duty, he did all he could to keep his own spirits up and to help his buddies do the same. They all worked hard to cheer up, distract, and entertain one another. There was always something going on, from card games to impromptu competitions—whether arm wrestling or seeing who could down the most pie. There were recitations of each man's best-remembered jokes and tall tales. There was good-humored teasing and talk of home.

Somehow, kitchen patrol, or KP, helped bring that talk to life. Gathered on deck just outside the galley—peeling potatoes or pulling the tough outer leaves off heads of cabbage—was nothing like strolling through Ma's kitchen. Yet there was something about the familiar routines of food preparation that evoked warm memories of home. Most men grumbled. They would rather be catching a few extra winks, reading a detective magazine, or enjoying a smoke and daydreaming about their sweethearts. Still, KP was a welcome excuse to talk about home and home cooking—and to argue about whose mother was really the best cook. Men bragged about their favorites, which they described in mouth-watering detail. Nat talked on and on about Ma's famous meat and spinach ravioli, made from scratch, of course, and bathed with the marinara sauce she simmered all morning on the back of the stove. He talked about Sunday dinners at his grandparents' house and how the minute he walked through the door, the complex combination of scents—garlic-infused olive oil, roasting meat, tangy fresh-cut vegetables, and freshly baked anise cookies—would envelop him like a hug. He described how Nonna herself would scurry from the kitchen in her faded, smock-style apron and give him a real hug.

Soon enough, everyone's attention would be drawn back to where they were and why. But for the moment, those familiar foods and the loving hands that prepared them were the only things on any man's mind.

KP, painted aboard the MS *Day Star*, 1943.

July 13, 1943
Arrive Nouméa,
New Caledonia

During this time Nat painted

FIRST STOP

COUNTRYSIDE

FINAL JOURNEY

OF PEACE AND WAR

SCUTTLEBUTT

December 5, 1943
Depart Nouméa,
New Caledonia

1943

CHAPTER
2

NOUMÉA, NEW CALEDONIA

=====

Finally, Island X had a name. After four weeks at sea, the 78th Construction Battalion was preparing to disembark at Nouméa in New Caledonia. About nine hundred miles off the coast of Australia, this sleepy colonial port was rapidly being transformed into a base that would serve as headquarters for the South Pacific Command (COMSOPAC). The camp at Magenta Bay, the jumping-off point for thousands of soldiers, sailors, and Marines heading to duty at forward areas, was just beginning to take shape on the low, rolling hills that surrounded the little city. It was July 13, 1943.

Marine cleans his
rifle —
Nov. 29-43 —

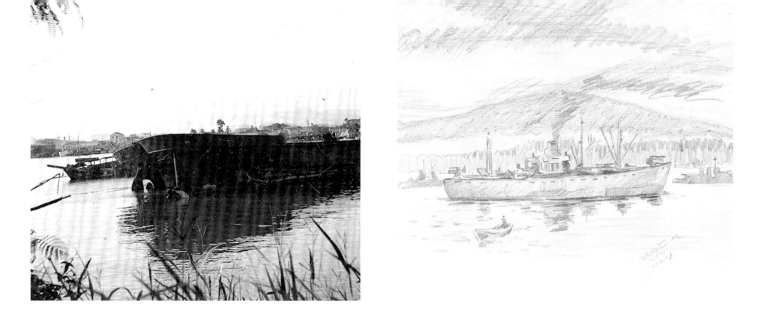

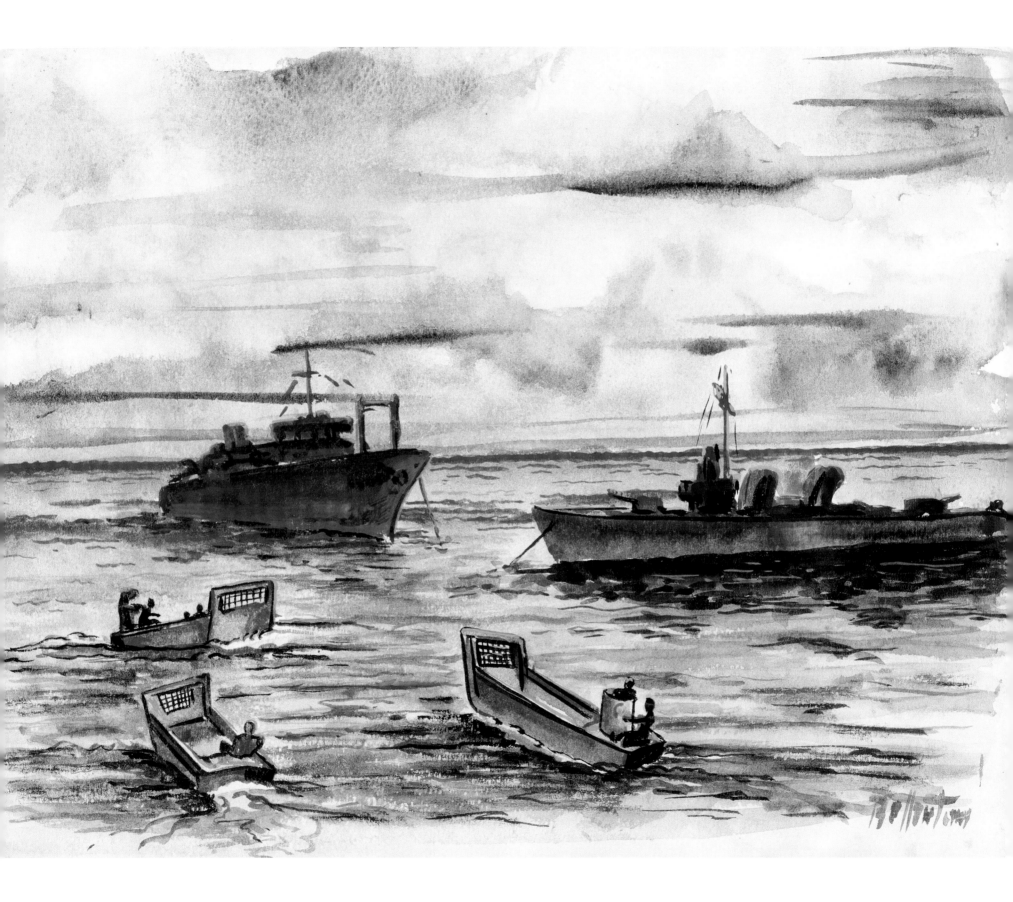

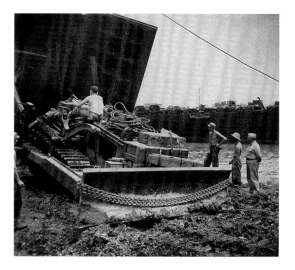

The men of the 78th would join other Seabee units working to expand this camp. They would grade landing strips; build warehouse, administration, and hospital buildings; construct storage tanks and plants for filling fuel drums; and install pipelines.

With his unconventional set of skills, Nat's assignments were more varied than most. Often, he worked as a draftsman. Usually, he would be the one to hand-letter the simple signs that identified buildings and provided directions on roadways. Always, he served on the staff of the battalion newspaper. Sometimes, he created artwork for interiors as different as officers' clubs and chapels. Occasionally, he would be called upon to solve a crucial camouflage problem. Eventually, he would contribute to one of the legendary morale-boosting programs of the war—painting nose art on the fuselages of Navy planes. These included humorous cartoon figures, clever names in bold lettering, and Alberto Vargas–style pinup girls. Often, it didn't really matter what his rate or rank was. He would simply lend a hand where needed.

The sun was warm but the breeze was cool and dry as the men on deck waited impatiently for gangway lines to be secured so they could hit the beach. *Maybe it won't be so bad,*

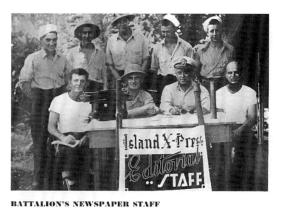

BATTALION'S NEWSPAPER STAFF

Using the dense tropical jungles of Finschafen (New Guinea) for a backdrop, the entire staff of "ISLAND X, PRESS", the Battalion's overseas daily newspaper, ceased work long enough one day to look into the camera lens, and here's the results. Seated (L to R) are: Mike D'Andrea, managing editor; Chaplain Robert J. Baird, editor-in-chief; Comdr. J. F. Cunniff, publisher; Jack Matthews, news editor. Standing: Nat Bellantoni, staff artist; Al Perron, Bill Snell and George Munson, cartoonists, and Eddie Hinson, press man. "ISLAND X, PRESS", which name was later changed to "TRACTOR TALES", was reputed to be the very first newspaper ever printed in Finschafen.

Nat thought as he shouldered his seabag. *But maybe it will be worse than my worst nightmare.* The tangle of shuffling men began to move. *Maybe I will come out of all this okay.* He stepped resolutely onto the slightly swaying gangway. *Maybe I won't come out of this at all.* Suddenly, his feet in their heavy work boots were firmly planted on solid ground for the first time in four weeks. *Maybe I should just stop thinking.* It was time to get to work.

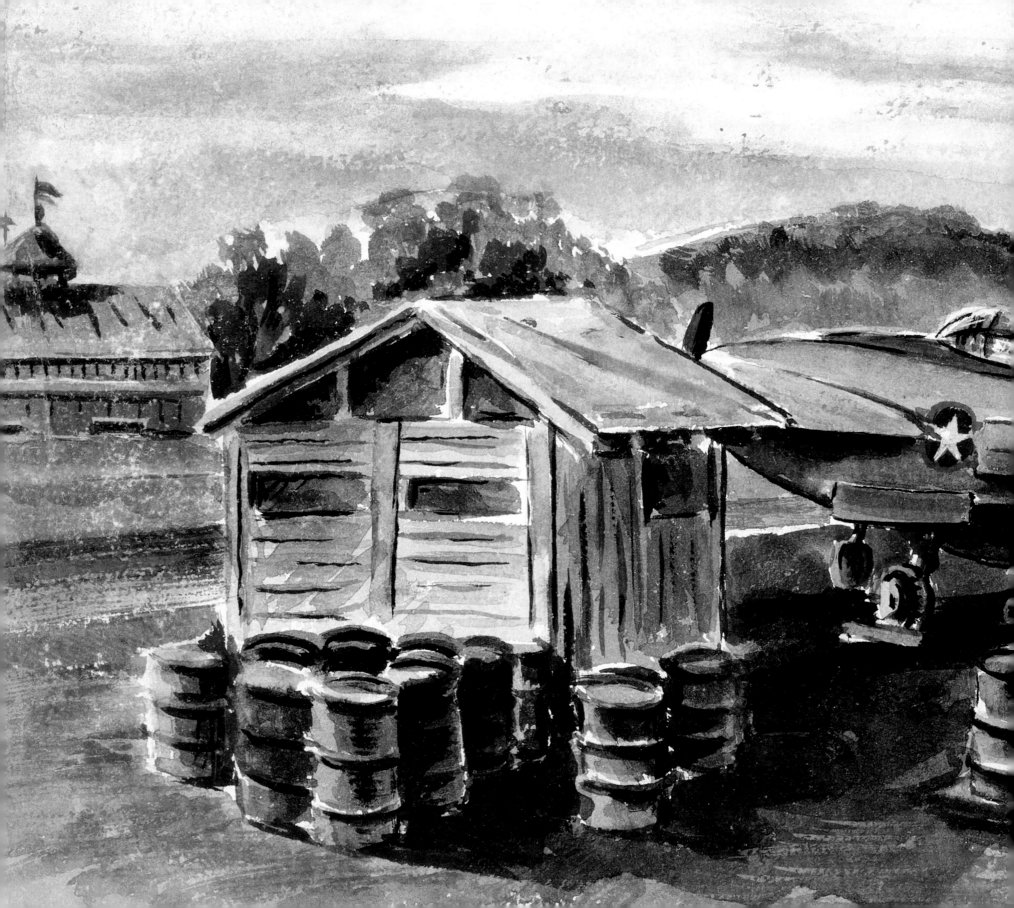

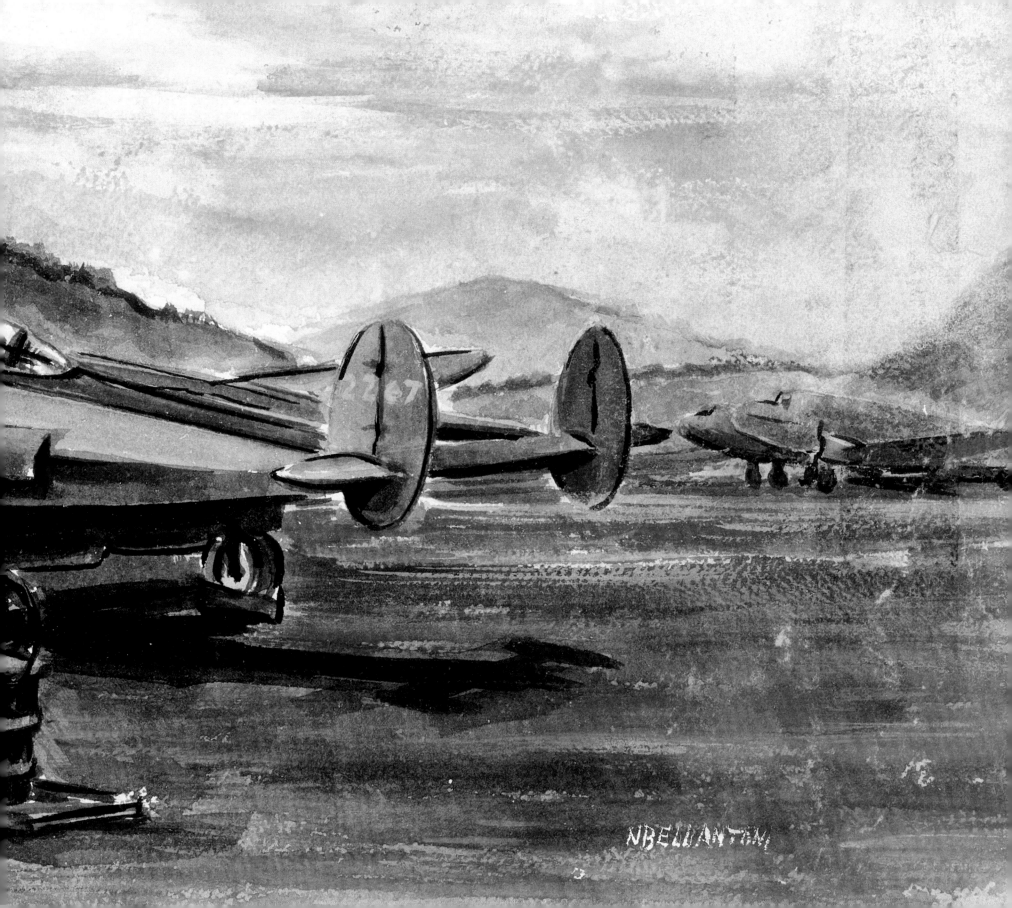

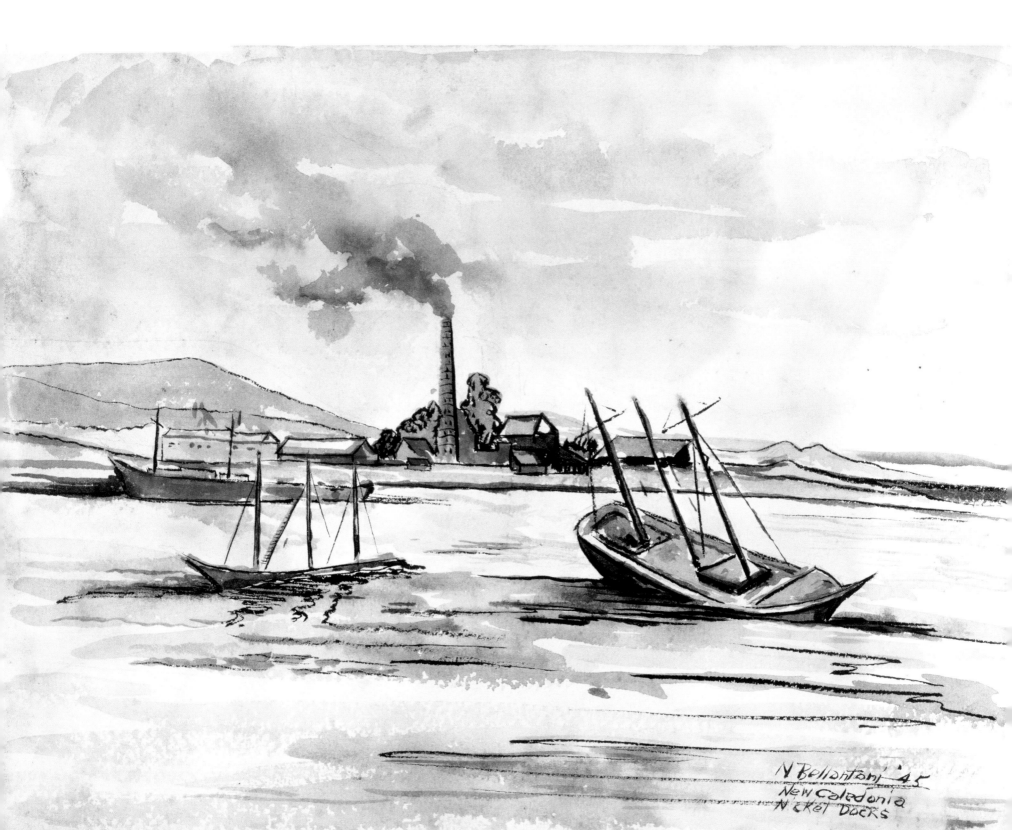

N Ballantoni '45
New Caledonia
Nickel Docks

FIRST STOP

When the *Day Star* cruised into Magenta Bay, Nouméa's well-protected harbor, Nat was struck by the irony of the visual contradiction. This had been a sleepy colonial outpost. Now it was a crucible for war. The vista before him underscored the new reality of his life. War was messy, chaotic, and ugly; yet off in the distance, almost miraculously, the natural world—the world without men—was still tranquil, majestic, and beautiful.

In the days that followed, the 78th settled into new routines: intense days of hard, heavy work, with sporadic breaks to rest and regroup. Nat used his hours of liberty to refuel his spirit in the way he knew best. One of the first paintings he made on New Caledonia was of the scene that had so impressed him at the mouth of Magenta Bay: derelict boats—small craft that seemed to be abandoned, half-sunk, forgotten, as this small island turned its attention from peace to war.

Nearby, onshore, was a smelter—just one of dozens on this mineral-rich island—with its tall stack spewing evil-looking smoke into the sky. The forlorn vessels in the foreground seemed to sense that they had become irrelevant. The stains and smudges of smoke that drifted heavenward suggested that the struggle for victory could require blotting out peaceful beauty. Yet the verdant hills in the distance stood calm and serene, bathed in the light of a pink-tinted dawn—proof that life and hope prevailed beyond the reach of human folly.

First stop, painted in Nouméa, New Caledonia, 1943.

COUNTRYSIDE

In the countryside outside Nouméa, a French plantation nestled against the hillside. Nat had packed his art supplies, ventured out beyond the camp and the town, and set up the little folding easel that a carpenter buddy had put together for him out of odd scraps of wood.

Viewed from the furrowed rows of a newly planted field, the scene looked idyllic. It reminded Nat of Irene's father's farm back in Reading, Massachusetts. There he had spent many pleasant, sun-drenched days helping plant and weed the huge vegetable garden, hauling feed for the turkeys, and repairing fences. This farm looked quite different, with its square, solid farmhouse, its red-roofed outbuildings, its lush vegetation. Yet somehow, it felt very much the same: serene, peaceful, and prosperous. Perhaps it was, and would remain so. There was a chance, because the fighting had not reached this particular island. Perhaps it never would.

Things were not so hopeful for thousands of farmers, fishermen, and families in places where the Japanese were in control or for the Allied fighters who were struggling to defeat them. Word was filtering back about just how tough the going was on other islands, where the weather was not so temperate, where constant rains, torrid heat, putrid swamps, and impenetrable jungles made daily life a misery. A tunneling, fanatical enemy exacted a ghastly toll of suffering for every inch of gain.

Nat thought about all this as he contemplated the tranquil farmhouse. New Caledonia, his first Island X, had been a good one to land on. How many more Island Xs would there be?

Countryside, painted in Nouméa, New Caledonia, 1943.

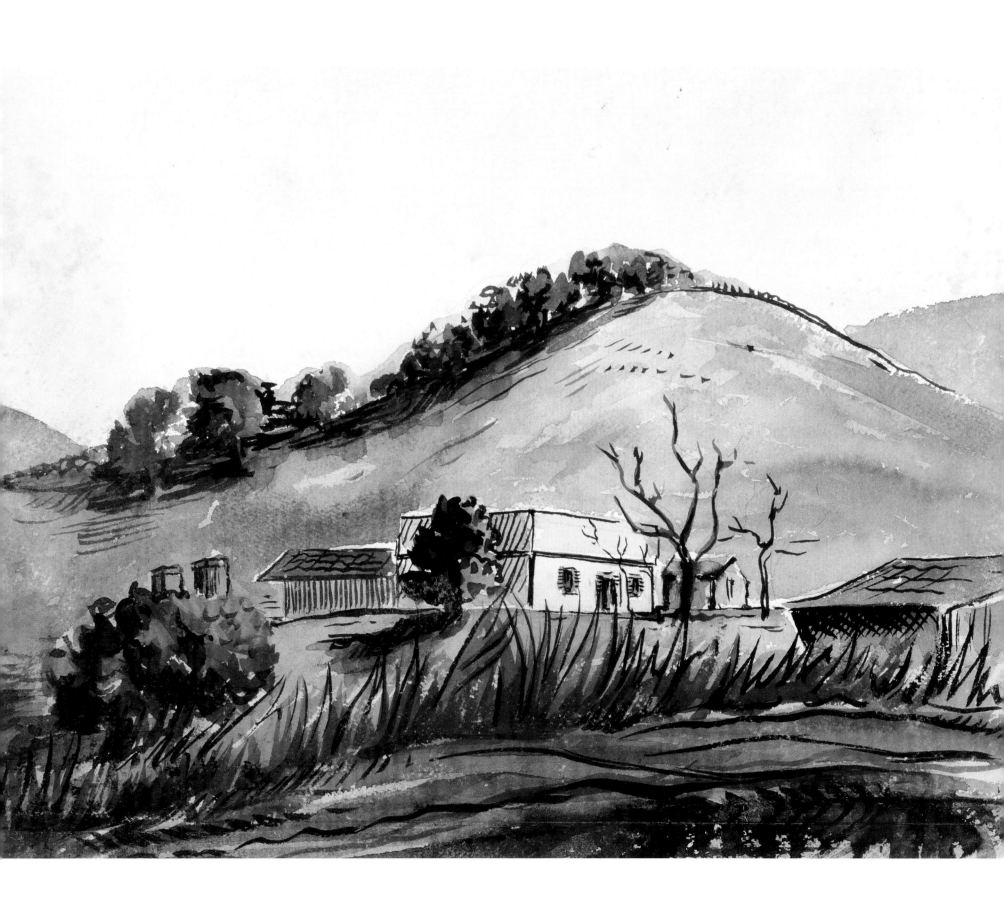

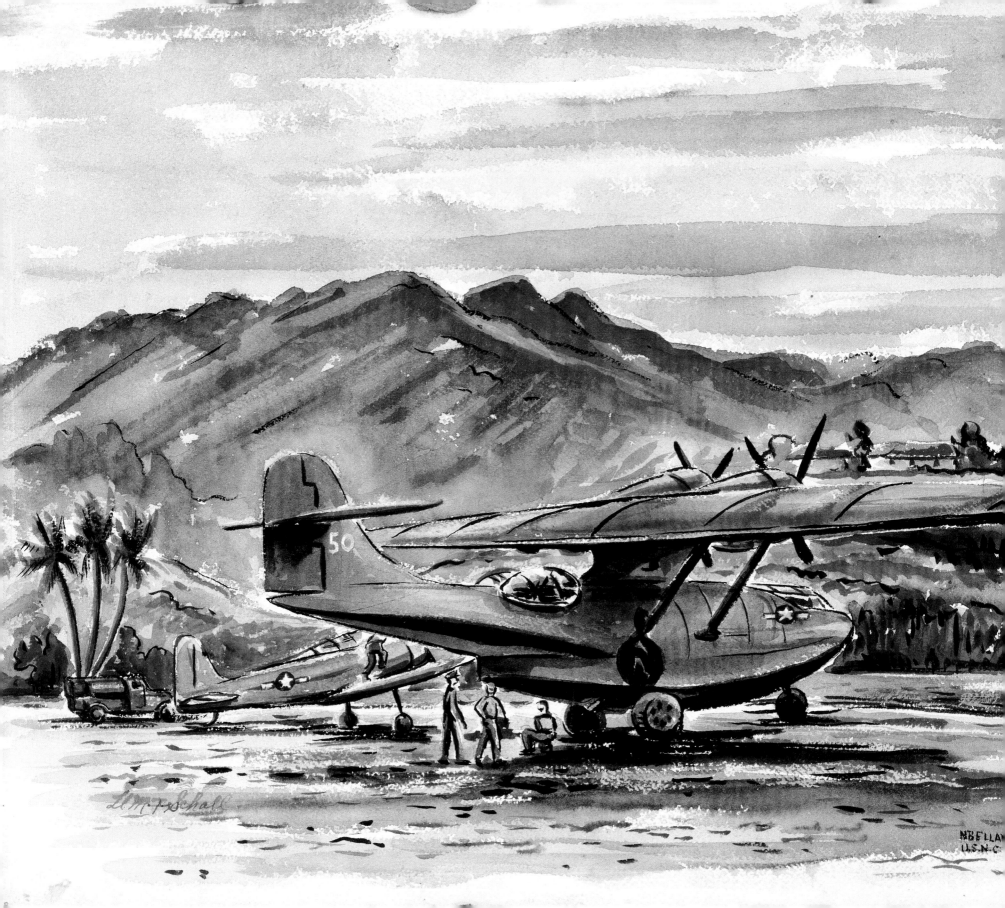

FINAL JOURNEY

It was an afternoon like so many others when Nat, with some free time, set up his easel. What caught his eye this time was a PBY Catalina parked on the hardstand beside the airstrip, its crew nearby. These versatile planes, when painted black, were deployed— usually at night—to stalk enemy shipping. In addition to reconnaissance, they were also sent to rescue downed American air crews. Sleek, silent, and stealthy, they were nick-named Black Cats.

With a very slow cruising speed—around 150 mph—Black Cats were easy targets for enemy planes. Although it was risky, they often flew low to be less conspicuous.

After finishing his painting of PBY 50, Nat decided he'd like to get the skipper to sign it. He walked over to the plane and found Lieutenant Merle Schall, who was happy to oblige. While his crew was getting the Cat ready for takeoff, Schall chatted briefly with Nat, who promised to get a photo made of the painting for the pilot to keep. They shook hands all around and said they hoped to meet up again. It was August 1943. The 78th remained at Nouméa until late November. Throughout those months, Nat kept an eye out for PBY 50. But it did not return.

Final journey, painted in Nouméa, New Caledonia, 1943.

Correspondence

On January 11, 1944, Nat sent Lieutenant Schall a note, enclosing two black-and-white prints of his painting. Less than a month later, he received a reply from the young pilot's mother. Mrs. Schall thanked Nat for the pictures of her son's plane and explained that his note had been forwarded to her because on the night of November 6, 1943, PBY 50 had been lost. While turning at a very low altitude, the plane had caught a wing in the water and crashed. Two crew members had survived. Lieutenant Schall was not one of them.

Questions

In July 1997—more than five decades later—Nat received a phone call from Michael Schall, Merle's nephew, who was writing his uncle's biography and had some questions. He told Nat he was not satisfied with the Navy's report about the crash and was hoping to get more information. Nat answered Michael's questions. They began corresponding.

Michael Schall eventually connected with PBY 50's two surviving crew members, who told him it was a Navy destroyer, the USS *Renshaw*, that had rescued them. The plane had been on a lookout mission over Empress Augusta Bay, in the Solomon Islands, when it went down. The airmen were to watch for approaching enemy ships or planes in order to protect the nighttime landing of Marines going ashore on Bougainville Island.

Answers

In February 1998, Michael was able to track down a man who had served on the USS *Renshaw*. Tom Redinger had been on deck the night PBY 50 went down. He remembered it vividly. The reason? PBY 50 had not crashed because its wing struck the surface of the water in the bay. The *Renshaw* had shot it down.

With troops being landed at night for a sneak attack at dawn, protecting the secrecy of the operation was of paramount concern. When the *Renshaw* spotted the unknown plane, it followed protocol and immediately looked for the automated IFF (identification, friend or foe) radio signal that all US planes transmitted continuously in such situations. But Schall had turned the signal off momentarily so he could send a requested weather report. That moment had sealed the fate of PBY 50.

On May 1, 1998, Nat and Irene Bellantoni met the Schall family in Elderton, Pennsylvania, and placed a rose on Merle Schall's headstone. With that, Nat felt the sense of peace about this beloved little plane that he had been seeking for fifty-five years.

"Maui" (A.T.)

- Maui -

OF PEACE AND WAR

Nat was continually struck by the vibrant colors, lush tropical vegetation, and stunning contrasts of Grande Terre, New Caledonia's main island. The island boasted vast plains against a backdrop of rock-crusted mountains, birds with electric blue and green plumage seen nowhere else on earth, and crystal-clear waters, home to vivid yellow, green, and even bright red fish. Nature's contrasts were a visual feast. The word "paradise" seemed not to be an exaggeration at all.

Again, Nat was painting. He had bypassed views that focused only on the natural beauty of the place. Screening out the impact of man's handiwork overlaying nature's spectacle was not what he wanted to do. On the contrary, he was determined to see, and show clearly, how the workings of the war had trespassed on this place. The intrusions were jarring to the eye and distressing to contemplate. Squat, square farmhouses and far-flung mining shacks were no longer remote outposts. Invasive military facilities and vehicles had spread over the landscape like an ominous tidal wave. As a heavily laden P-39 approached the airfield at Nouméa, it crossed paths with an Army truck, just one of dozens of ant-like vehicles incessantly droning by. Meanwhile, just out of sight were the pounding, banging, screeching, whirring sounds of men at work, busily cobbling together the buildings where soldiers and sailors would live, work, and wait.

All this activity had created a jumble of objects that simply didn't seem to belong in the same small frame. This island had been named by a Scottish sea captain because it reminded him of home. From it would be launched the war machine that would ultimately safeguard this beautiful place and free so many others from the grip of tyrants. But at what cost? Nat shook his head. He knew the answer. The cost was beyond calculation.

Of peace and war, painted in Noumea, New Caledonia, 1943.

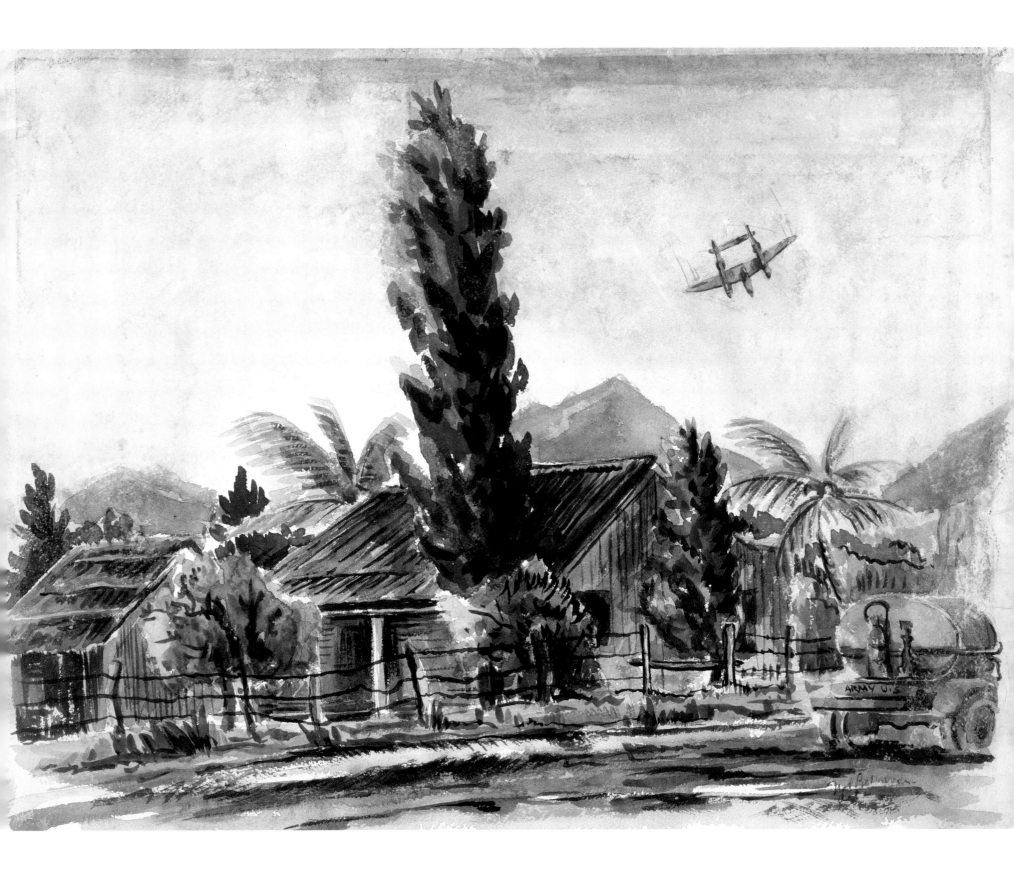

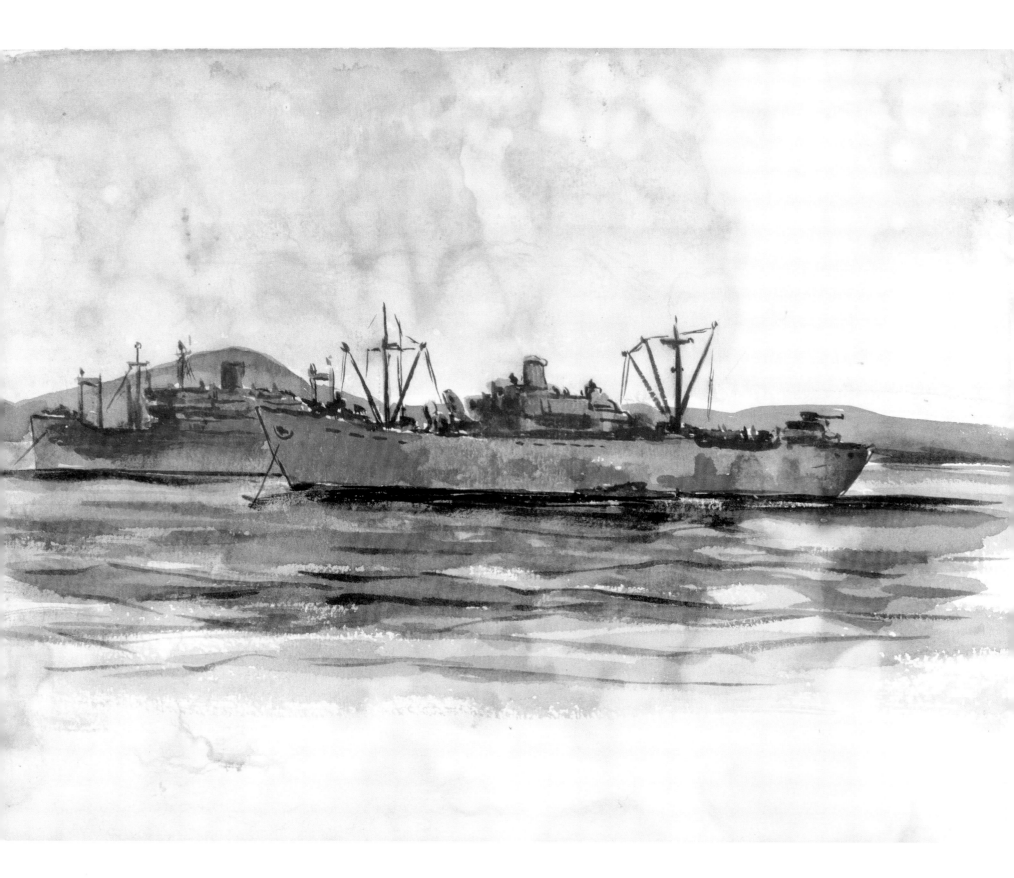

SCUTTLEBUTT

As Nat sat on the dock, his seabag propped behind him for a backrest, he sketched the ships at anchor on Magenta Bay. Later he would turn the sketch into a painting. Soon he would be boarding one of those ships. But right now was, well, right now. He was here. The bay was glassy and calm.

The voices of the men aboard the ships carried across the water, as did the occasional slap, slap, slap of wavelets against steel hulls and the quiet clanking of anchor chains. There was something reassuring and homelike about the simple sounds of sailors aboard ship going about their predictable routines. Odd to think of Navy life as homelike, yet that's what it had become.

Nat noticed the way the late afternoon light darkened the water and shifted the utilitarian gray of the ships to deep blues and purples. By an odd trick of light, the sun, so low in the sky, sent a splash of red across the hull of the nearest ship. Ordinarily, such coloring might suggest danger. Today it suggested only warmth. There was a sense of safety here in this place that had become familiar. But tomorrow all that would change. The 78th would be at sea again, headed for another unknown destination.

There was much speculation among the men, lots of scuttlebutt. Where would they be headed? Some thought the Solomons. Some guessed the Gilberts. Others suggested it would be New Guinea. All were places where the fighting had been fierce these past couple of months.

Nat knew, as everyone knew, that once a toehold was established in a forward position, there would be an urgent need for airstrips, docks, and bases so that the Allies could move forward—ever forward—toward Japan.

How long would it be until the 78th reached its next Island X? How long after that before they felt, as they now did here, that they were safe?

Scuttlebutt, painted in Nouméa, New Caledonia, 1943.

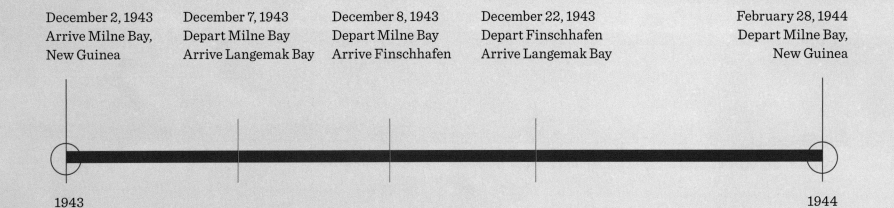

December 2, 1943
Arrive Milne Bay,
New Guinea

December 7, 1943
Depart Milne Bay
Arrive Langemak Bay

December 8, 1943
Depart Milne Bay
Arrive Finschhafen

December 22, 1943
Depart Finschhafen
Arrive Langemak Bay

February 28, 1944
Depart Milne Bay,
New Guinea

1943

1944

3

MILNE BAY, NEW GUINEA

The USS *Maui*, a converted luxury liner, transported the 78th Construction Battalion to its next Island X. After five days of zigzagging to avoid Japanese patrols—west to the coast of Australia, then back across the Coral Sea—the *Maui* finally anchored in Milne Bay, on New Guinea's eastern tip. Massive transport vessels drew alongside. Men and cargo were quickly transferred and within days were headed north along the coast. They passed Buna, where the fearsome battle over the treacherous Owen Stanley track had ended, finally, in Japanese defeat. Under drenching rains, they headed across Huon Gulf at night.

In the morning they anchored in Langemak Bay, just north of Finschhafen, which would be the site of their next major assignment. Before disembarking, the men ate what they knew would be their last good breakfast for a while. P-38s soared overhead to cover their landing, like mother hawks protecting their nests. Japanese airbases were still operating within easy striking range.

SURROUNDED BY FIGHTING

Even as the men were making their way ashore, Australian troops, just a few miles away, were driving the enemy northward. The men could hear guns in the distance. But they had no time to stop and listen. Their first task was to unload their equipment and supplies. This took several exhausting days and nights, with all hands sleeping in the open and food prepared camp-style using improvised cooking facilities until a proper mess hall could be constructed.

The men were soaked at least once a day, nearly every day, by tropical rains. They were always surrounded by the distant booming of artillery, the oppressive heat of the jungle, mud (lots of it), mosquitoes (plenty of them), and the invisible threats of malaria, dengue fever, jungle rot, and dysentery. For a while, the 78th was operating farther north than any other American unit in the South Pacific. Air alerts occurred every night and several times each day, sometimes followed by falling bombs.

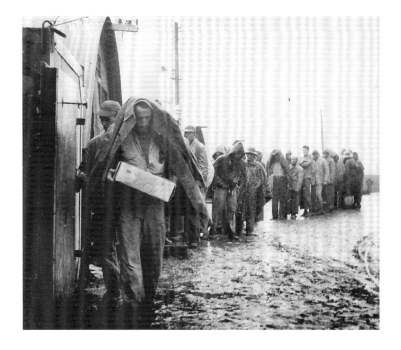

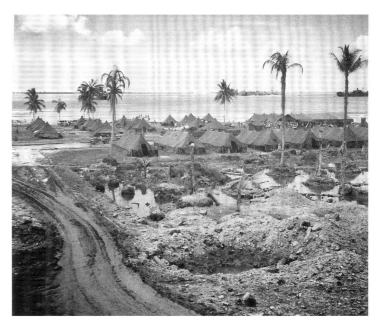

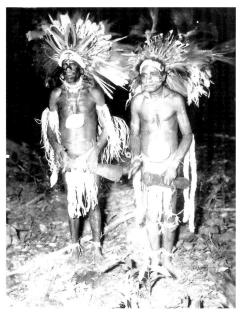

The Seabees of the 78th would wait nearly two years to celebrate winter holidays with their families at home. On Christmas 1943 they unloaded the biggest shipment of mail they received while overseas; on Christmas 1944 they held services in an improvised shelter on a baseball field in New Caledonia.

Merry Christmas 1943

It was mid-December 1943. On December 21, Nat would turn twenty-three. Four days later, it would be Christmas. But it would be unlike any Christmas he had ever known. No presents. No family. No fabulous Italian meal. Instead, Christmas would be a workday like any other. There was a base to be built. And a war to be won.

Jungle Bells

'Twas the night before Christmas and all through the tent,
Not a creature was stirring, the rats had all went.
The helmets were hung by the foxhole with care
In case a few Zeros might buzz through the air.

The soldiers were sleeping, dreaming of things
Like vine-covered bungalows and wedding rings,
Of beautiful blondes and thick juicy steaks,
Of sundaes and sodas and Mom's chocolate cakes.

An air of contentment crowded the place
And satisfied smiles were on each GI's face;
The stockings were nailed to the center pole tight,
Moldy and green in the faint evening light.

Whether home or in jungle, this time of the year,
Living secure or in perpetual fear,
The holiday spirit stands out like a light,
A symbol of justice, of right over might.

So they slept, their thoughts were the same:
They saw all their dear ones and called them by name.
May your Christmas be merry and the coming year find
Dear ones together—the war far behind.

—Author Unknown

The guys got a chuckle out of this poem and passed it around. Eventually, Nat made himself a copy. Before tucking it between the pages of a sketchbook, he scribbled a note across the bottom: *More truth than poetry!*

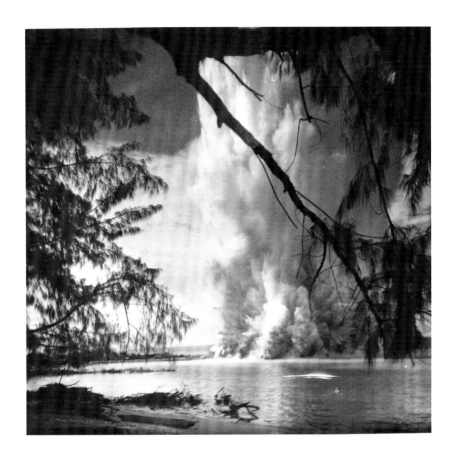

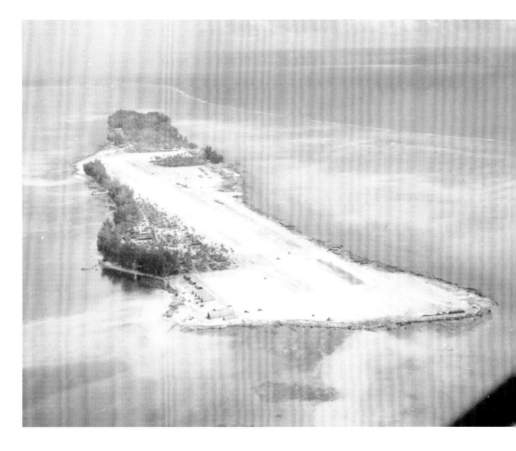

Blasting through coral reefs was an unfortunate necessity for the Seabees as they built docks for US naval vessels on Pacific Island bases.

Though only one and a half miles long and a quarter mile wide, Ponam Island in New Guineau was a critical tactical location for the US Navy during World War II. On Ponam Island the 78th Construction Battalion dredged swamps in order to build a massive repair facility for American aircraft carriers.

The Seabees were tasked with converting the tiny island of Ponam into an airfield where fighter planes from aircraft carriers could safely land when ongoing battles preventing returning to their home carriers. The Seabees dynamited underwater reefs and mined the displaced coral to pave Ponam's runway. They completed this urgent work in just ten weeks.

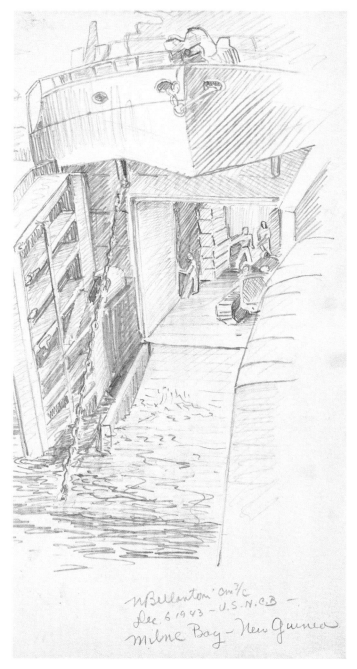

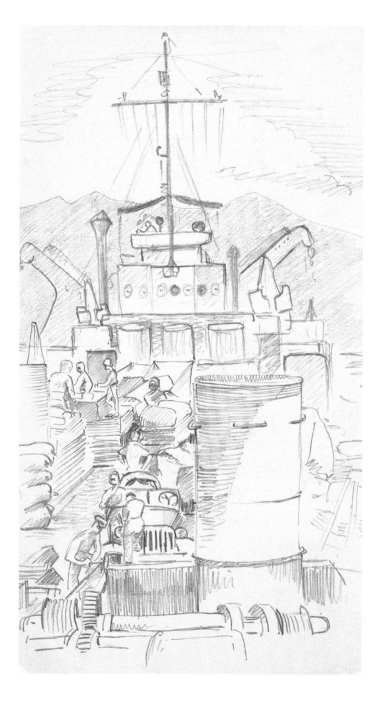

Nat's sketchbooks were crammed with drawings of construction projects, ships at sea, the relentless work of transporting men and equipment, and Seabees at work and at rest.

March 2, 1944
Arrive Los Negros,
Admiralty Islands

May 1, 1944
Move from
Los Negros
to Manus

May 14, 1944
Move from
Los Negros
to Ponam

During this time Nat painted

MUD, MUD, MUD

QUONSET HILTON

CATHEDRAL SQUARE

December 8, 1944
Depart
Admiralty Islands

1944

CHAPTER

4

ADMIRALTY ISLANDS

═══

Once it became clear that Japanese forces would be driven off New Guinea, the Allies set their sights on the Admiralty Islands two hundred miles north and east. The Admiralties—Manus (the largest), Los Negros, Ponam, and numerous smaller islands—offered plenty of space for a major US base and an ideal strategic position for moving north.

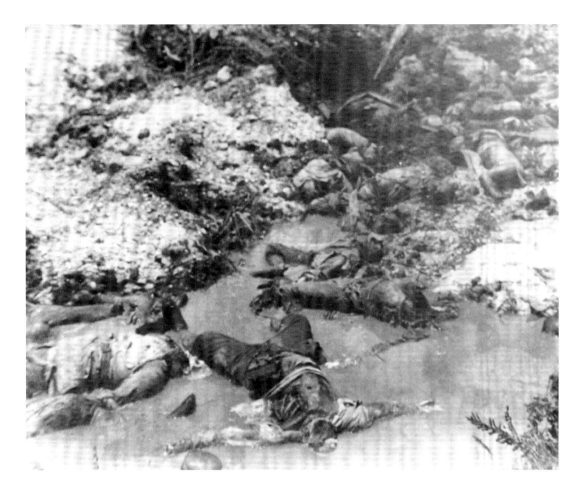

It was March 1944. The 78th Construction Battalion was transferred to these islands in several waves. Those who arrived first found that the area assigned to them for bivouac had been a battlefield only a few days earlier. They saw destruction everywhere—abandoned foxholes, huge bomb craters, splintered palm trees, ruined equipment, even enemy dead, not yet buried. Just a few hundred feet away, artillery was blasting away at Japanese fighters who were stubbornly holding their positions. Nat took a long, slow look around, then tossed his seabag aside. So this would be it—his third Island X.

Outsmarting reality

The men of the 78th worked their fastest, barely stopping to eat and sleep. They knew that the Army, Navy, and Marine Corps were all waiting. As soon as this base was operable, battles would be launched. Every man pitched in. Rate and rank and regular jobs were irrelevant. For every day's delay, the Japanese were building more pillboxes, reinforcing more bunkers, booby-trapping more beaches. The days passed quickly. Yet, somehow, the months did not. It could take weeks for a letter to leave Nat's tent in the South Pacific and arrive at Irene's home fourteen thousand miles away, and weeks more for him to receive her reply.

Nat daydreamed about finding a way to magically cross all those miles. A grass skirt purchased from one of the islanders sparked an idea. Nat sent it to Irene and she sent back a snapshot. Meanwhile, Nat had wrapped himself in a native sarong and asked a buddy to take a picture. With both photos in hand, all it took was a little darkroom magic. There they were together! It was fun. It was romantic. But . . . it wasn't enough.

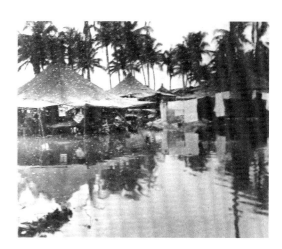

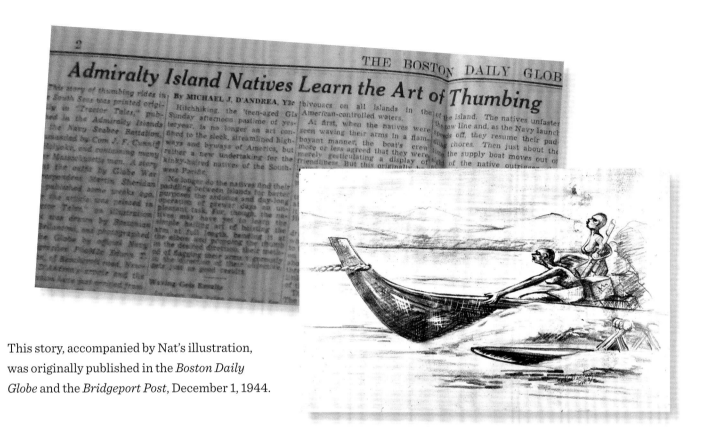

This story, accompanied by Nat's illustration, was originally published in the *Boston Daily Globe* and the *Bridgeport Post*, December 1, 1944.

Hitchhiking—South Pacific style

Throughout the South Pacific, the islanders were eager to help the US Navy defeat the Japanese. They often served as porters, scouts, messengers, and able seamen. They used their outriggers to transport men and supplies to landing places too shallow for Navy longboats. In return, US sailors were more than willing to assist the natives when and how they could.

One of the easiest things the sailors found to do was to provide an impromptu towing service. An islander who saw a Navy launch overtaking him would wave. The Navy boat would slow down and throw out a towline. With the line secured, the outrigger would zoom along. As he approached his destination, the native skipper would signal. The Navy boat would slow down, wait for the line to be released, and then speed away. The crews of both boats would be left smiling. These simple encounters were a welcome distraction from the grim business of war.

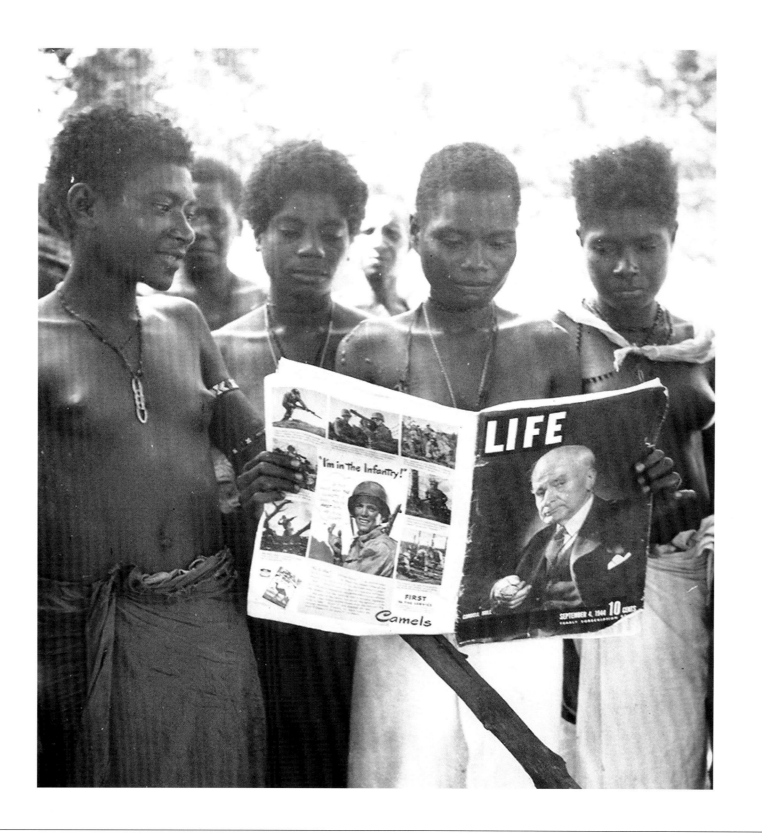

MUD, MUD, MUD

Only two degrees south of the equator, the Admiralties are extremely hot and extremely humid, with an annual rainfall in excess of 150 inches, most of it falling between December and May—monsoon season. And of course, this being March, it was the middle of monsoon season, which meant rain, rain, and more rain.

Nat was tired of being wet all the time. Even when it wasn't raining, the air was so saturated that it was impossible to get anything truly dried out. Finally, there was an afternoon when rain wasn't falling and he had an hour of free time. Nat grabbed his watercolors, a few sheets of paper, and his easel and set out to look for a spot that would capture the feel of all this wetness.

He walked to a place where bulldozers had just churned their way through a morass of gooey red mud, grading a roadway to an encampment of billets that was swiftly being constructed. He noticed how the mud stuck to the blades of the massive earthmovers. Overhead, even though patches of blue sky struggled to break through, masses of clouds hovered darkly, mocking the men's relief at the brief respite from rain. Swiftly turning from pale gray to charcoal, the clouds were simply pausing to gather more wetness. Nat could see this, so he worked quickly. He noted how the paper itself had absorbed moisture from the air, thickening in a way he could actually feel. His paints, tacky and dense, dragged at the tip of his brush. The pigment clung to each sable hair as he shook his brush in the water jar.

Only the trees and low vegetation looked happy. More intensely green than on a sunny, clear day, they seemed to know this was the time to drink their fill, for once the monsoons ended, they must make do with the skimpy, fair-weather rains that prevailed for the rest of the year. All this—the gooeyness of mud, the gathering moisture in the clouds, the enthusiastic jungle greenery striving to reach for even more water, and the density of the paints—was visible, somehow, in Nat's painting. Ever afterward, when he looked at it, he could almost feel the clammy wetness.

Mud, mud, mud, painted in the Admiralty Islands, New Guinea, 1944.

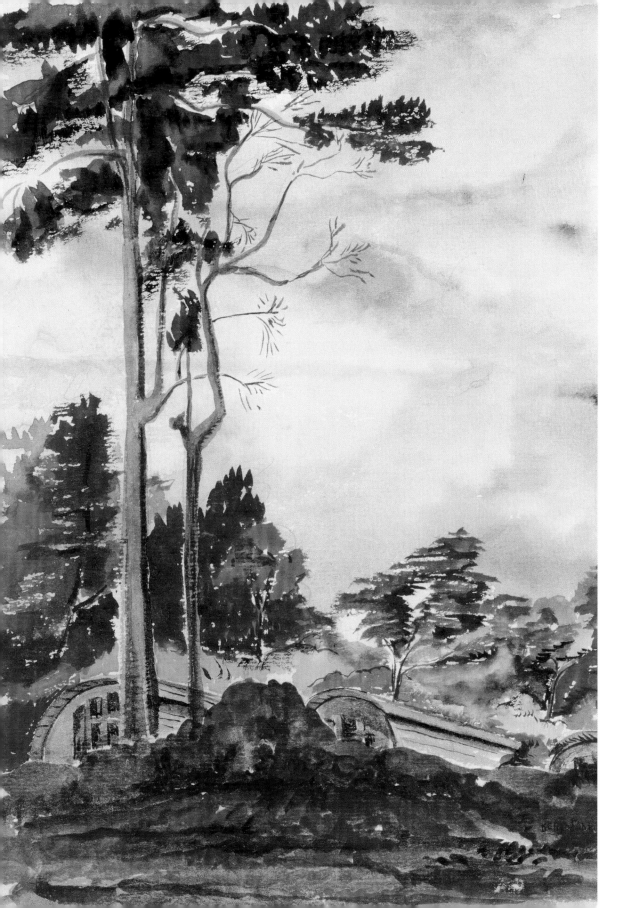

Mud

Overcast skies and cloudbursts.
Rain pouring down all around.
Thunderbolts of lightning and howling winds.
Mud—thick mud, on the ground.

Sheets of rain to the right and left.
Sheets of rain all around.
The impenetrable curtain closes in.
Mud—thick mud, on the ground.

The wind and the rain cease suddenly.
Just stand and look around.
The sun is radiant in a clear blue sky.
Mud—thick mud, on the ground.

And so it goes on, all day and all night.
There is nothing else to be found,
In this strange land of make-believe,
But mud—thick mud on the ground.

Written by Irving Miller
US Navy 78th Construction Battalion
Bear Point, Manus, 1944

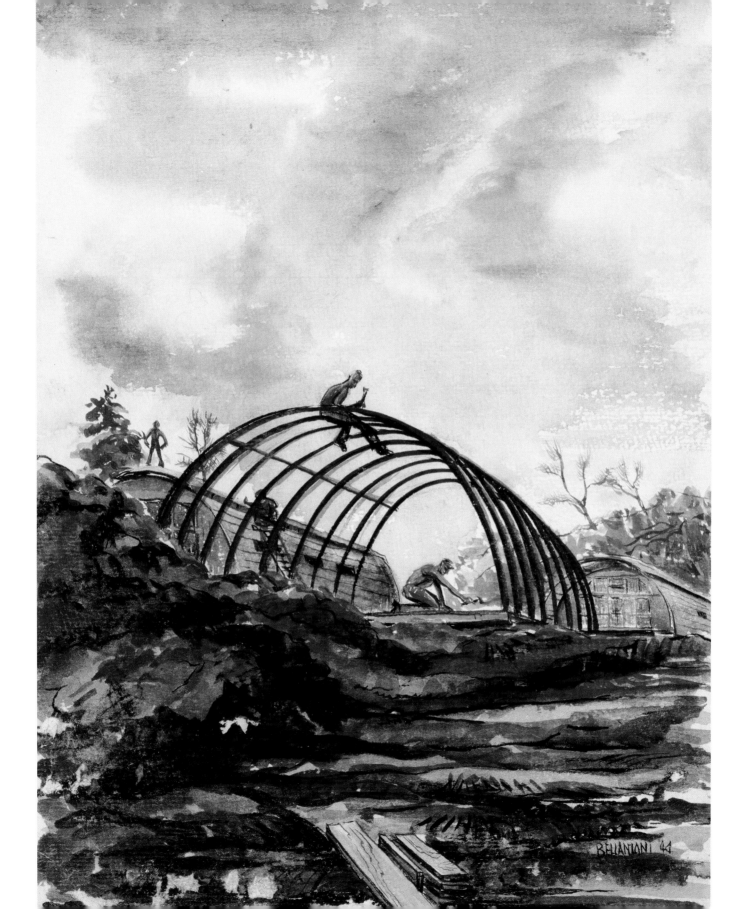

QUONSET HILTON

By now, the Seabees had come to regard this stifling tropical environment as normal. They all knew that heat, humidity, bugs, snakes, constant rain, and thick, deep mud were to be expected. But that did not make these annoyances and discomforts any easier to cope with.

In just five months, working in these far-from-ideal conditions, the 78th alone had constructed a ten-thousand-man mess hall and galley, a chapel, a theater, a library, showers and latrines, plus gasoline and water storage tanks, roads, and docks. But the structures that the men worked on with more energy and enthusiasm than they had felt for any other project were the Quonset huts—nearly three hundred of them—that would be used for housing. Each one could accommodate twenty men. And sure enough, as each was completed, twenty men abandoned the nearby tent city and moved in. These permanent quarters were the first truly indoor billets the Seabees of the 78th had occupied since leaving the United States. Nat took great pleasure in capturing the scene. How welcome those huts were. And what a contrast their neat geometric shapes were to the mounds of mud that surrounded the building site. Carpenters, masons, and sheet metal workers, all shirtless in the heat, worked quickly and skillfully, assembling frames, laying floors, securing roofs.

Each hut completed meant twenty men under a waterproof roof, off a mucky mud floor, shielded by screens that kept out swarming mosquitoes. From Nat's perspective, the curved supports of the hut just being framed stood out boldly against the sky. In fact, the sky, in a pause from its incessant pouring down of rain, actually brightened a bit as Nat transferred to his watercolor paper the lively scene of the men at work.

Those support frames, Nat thought, *look like upside-down smiles*. No doubt the men who would be sleeping in these huts would be smiling when they made up their cots in a truly dry place for the first time in well over a year. As he thought about this, and as he put the finishing touches on his painting, Nat smiled, too.

Quonset Hilton, painted in the Admiralty Islands, New Guinea, 1944.

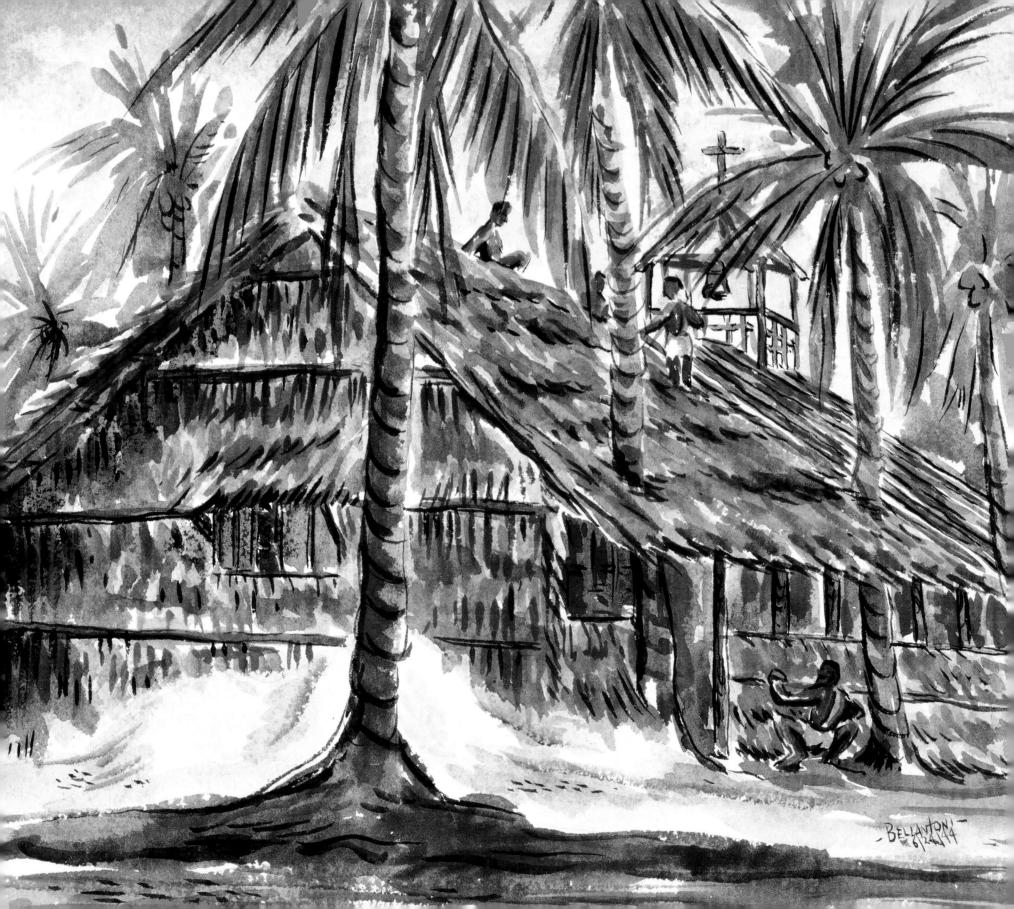

CATHEDRAL SQUARE

Memories

At night in his cot, Nat often would close his eyes and visualize scenes from home. Sometimes it was the family around the kitchen table. Sometimes it was the park near the house where he and his buddies used to put together pickup games of baseball or basketball, or just hang out and goof around.

Sometimes, a surprise even to him, the scene that came to mind was the soaring arches of the cathedral. The Cathedral of the Holy Cross on Washington Street in Boston's South End was Nat's parish church, his spiritual home. The Bellantoni house was only a ten-minute walk away. It was here that he had attended Mass nearly every Sunday of his life. As an altar boy, he had listened carefully to the sonorous Latin intonations of the priest, attentive lest he miss his cue to respond. But it was when he sat during the readings of the Epistles and stood during the Gospel that he truly believed that God was right there in the cathedral. For that's when Nat could look around—at the majestic architecture, the magical colors of sunlight cascading through stained glass, the intricate carving of the high altar. Always, it was that visual glory that left him with a sense of inner peace.

Inspiration

It was only by chance that the Seabees ended up building a place of worship so very different from a standard-issue military chapel. The inspiration came from their chaplain, Father Kofflin.

On Ponam, many islanders lent a hand to the men of the 78th, who were working as hard and as fast as they could to convert this tiny island into an airfield urgently needed for planes unable to return to embattled carriers. There was no thought of anything else until the day Father Kofflin happened upon a ramshackle mission chapel in a native-cultivated coconut grove. At chow that night, the priest mentioned to the men how sad it was that the nearby villagers—converted by early missionaries—were worshipping in a shaky structure that didn't even have a decent roof.

That casual comment launched the men into action. The natives had given them so much help. The Seabees would return the favor. If the islanders would fell the trees for lumber, they would volunteer their scant off-duty time to do the building. The islanders trekked deep into swamps on nearby islands to gather water-repellent

Cathedral Square, painted on Ponam, Admiralty Islands, 1944.

grasses for thatching the roof and walls. Meanwhile, Seabee metalworkers repaired a cracked bell they had salvaged from the mission at Finschhafen, even miraculously restoring its beautiful tone. Nat painted the reredos—a South Pacific version of the spectacular carving above the altar in Boston.

With that task done, he set up his easel to document the exciting scene as the natives put the finishing touches on the structure. There stood the building, four-square and strong, its golden covering secure. The surrounding trees gently waved their graceful approval. And the bell tower with its simple cross promised to shower down blessings.

Peace

The chapel was completed in just three weeks. For the villagers, it was a new and greatly appreciated spiritual home. For the Seabees, it offered opportunities for quiet contemplation as well as regularly scheduled weekly worship—Jewish, Protestant, and Catholic. For Nat, for the rest of his time here, this was his very own Cathedral in the Pacific. Although the visual details were very different from the ones at the cathedral in Boston, whenever he attended Mass here, the sense of wonder, inspiration, and peace Nat felt was the same.

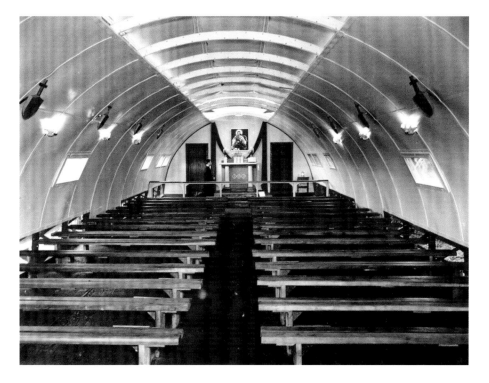

The 78th also built a conventional military chapel on Manus Island. Nat created artwork for its interior (and for an additional chapel the Seabees would build in the months ahead). But of all the places to pray that Nat worked on, or happened upon, in the South Pacific, "The Cathedral" always remained closest to his heart.

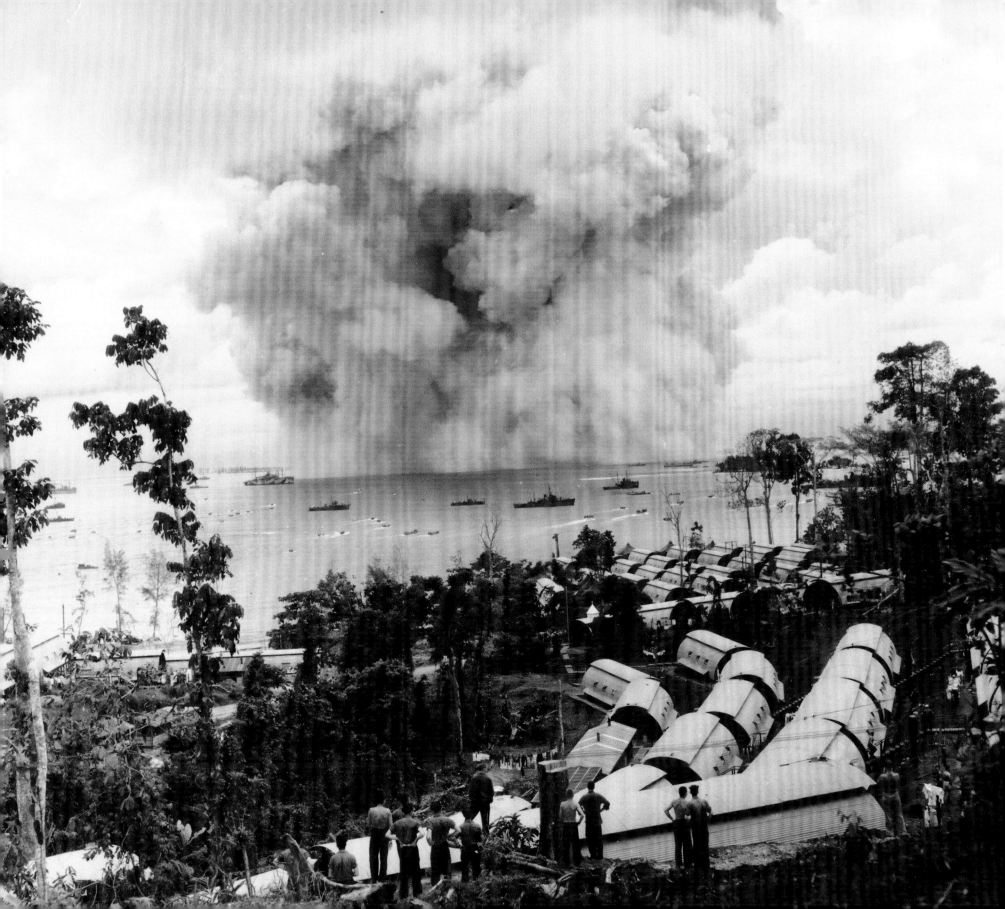

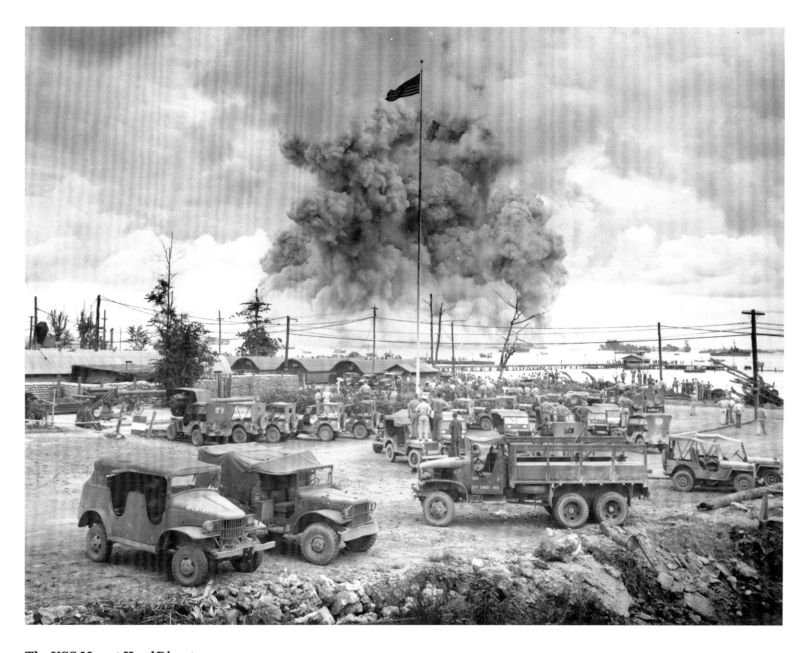

The USS *Mount Hood* Disaster

The ammunition ship exploded and was completely obliterated in Seeadler Harbor
on November 10, 1944, with the loss of all 350 men onboard; damage and casualties
to other ships in the Harbor were extensive. The men of the 78th Construction
Battalion participated in the extensive repairs necessitated by this explosion.

December 2, 1944
Leave Admiralties

December 9, 1944
Arrive Nouméa,
New Caledonia

May 2, 1945
Leave Nouméa,
New Caledonia

1944

1945

5

NEW CALEDONIA, SECOND TOUR

In early December 1944, with their work completed in the Admiralty Islands, the 78th Construction Battalion was ordered back to New Caledonia to await reassignment.

As the men boarded the USS *General Morton* at Manus, they carried haunting memories. They were leaving three comrades behind. And just a month before, they had helped with repairs to ships damaged when the USS *Mount Hood* exploded in Seeadler Harbor, a tragic accident that killed everyone on board.

The men spent much of their time aboard the *Morton* reviewing the progress of the war and speculating about next steps. Nat and the others had heard about the Great Marianas Turkey Shoot—a nickname for the air and sea battle in the Philippine Sea that ended with the destruction of Japan's aircraft carrier fleet. Then came the US victory on Saipan.

Nat thought about promises as he gazed out to sea from the deck of the *Morton*. General Douglas MacArthur had kept his promise to return to the Philippines. Would Nat be able to keep his? His promises had been made to his mother, his father, and most of all to Irene: to return, to come home— alive, and preferably in one piece. For him to fulfill those promises, US forces still had to win this war. And the closer they came to the Japanese homeland, the more difficult, the more devastating, the more deadly, this war became. But for now, the 78th US Naval Construction Battalion was moving away from the front lines rather than toward them.

On December 9, the *Morton* docked in Nouméa, New Caledonia, the port where the battalion had arrived from the US mainland seventeen months before.

Each Seabee was given a *Pocket Guide to New Caledonia* issued by the War Department. Nat thumbed through the little book as he waited among the milling cluster of men on deck. The first pages emphasized the strategic importance of this cigar-shaped island. Then came a little history and geography, facts about the people and their customs, and a glossary of French words and phrases so the men could more easily communicate with the islanders.

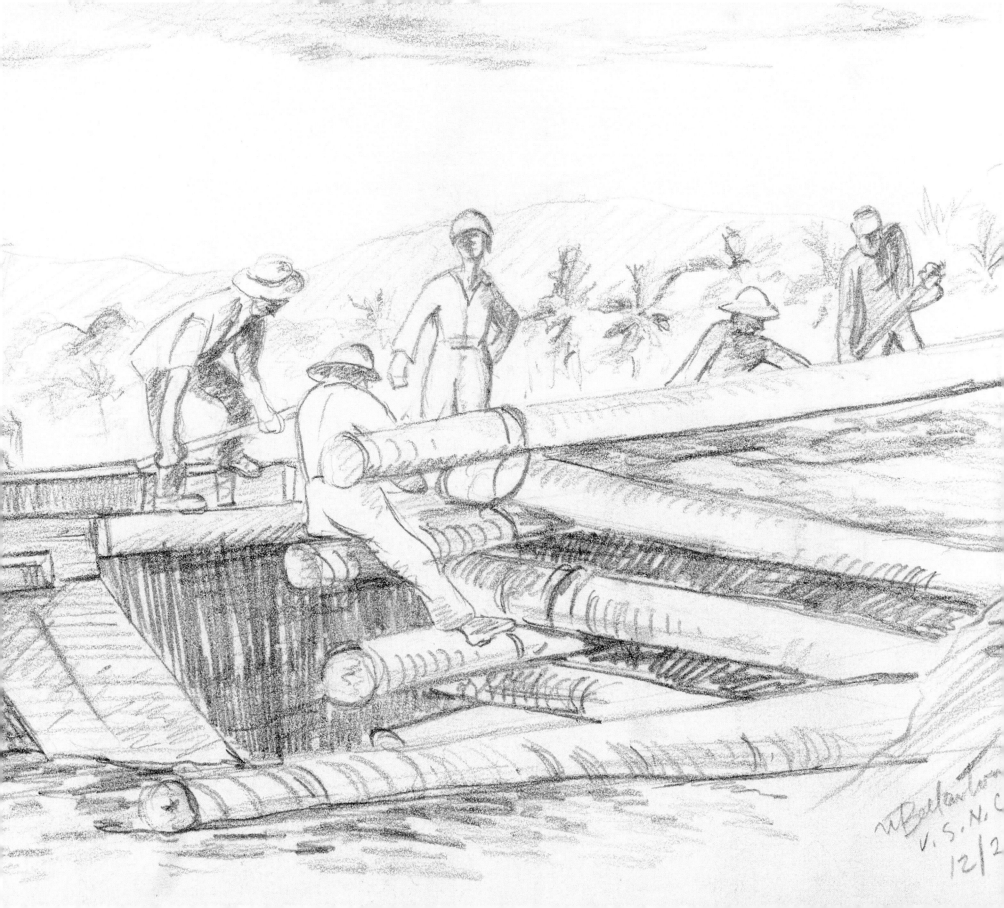

INTERLUDE IN NEW CALEDONIA

New Caledonia was, literally, a breath of fresh air. They had left behind the torrid heat of the equatorial zone.

This second Christmas in the South Pacific would be far more festive than the first. Father Kofflin had made sure of that. The ballfield was converted to an open-air chapel complete with greenery and sparkling lights. Midnight Mass was followed by Christmas morning services, turkey dinner, Australian beer, and packages from home. And no mud! After supper, the battalion's best pianist sat down at the old upright in the mess hall and led an impromptu sing-along—everything from hymns and carols to show tunes. Nat's voice was among hundreds. For a couple of hours the perpetual anxiety of war was nearly forgotten. The ache of being away from loved ones was lessened a bit. It was not like being home. But for here, for now, it was as good as Christmas could be.

Compared to the heavy work they had done in the jungles of New Guinea and in the torrid heat and torrential downpours of the Admiralties, the 78th's assignments here seemed like child's play—devising a system of wooden troughs for irrigating a victory garden, completing various welding and wiring projects, building a white-clapboard, steeple-topped chapel at Mount D'Or. And yet, as weeks and then months went by, the men lived with an unspoken sense of perpetual anxiety—for they knew that they were inevitably headed to the ultimate Island X.

During the battalion's second tour on New Caledonia, one of the men rescued an orphaned baby rusa deer, indigenous to the island. The men named it "Bambi" and instantly adopted it as their mascot. In the photograph at the top of the page, Nat's buddy, photographer Ed Keegan, offers Bambi milk from a modified beer bottle. Nat's oversized portrait of Bambi hung in the studio he and Ed shared for the remainder of their time on this Island X.

Little Bambi tells Ed that
he loves his milk best in
beer bottles —

Bambi is 2½ weeks old
Eddie 38 yrs old – I
keep telling him he doesn't
look a day over 60 —
What do you think?

New Caledonia offered the men a respite from the relentless work schedule of the previous seventeen months, the stress of living and working in combat zones, and the oppressive heat, humidity, and drenching monsoon rains of the tropics. There were still construction projects to complete, but there were also welcome breaks for organized sports. During this period they enjoyed building the Kofflin Field Recreation Area, dedicated to their chaplain, John D. Kofflin. The battalion's baseball team also proudly won the coveted "SoPac League" championship.

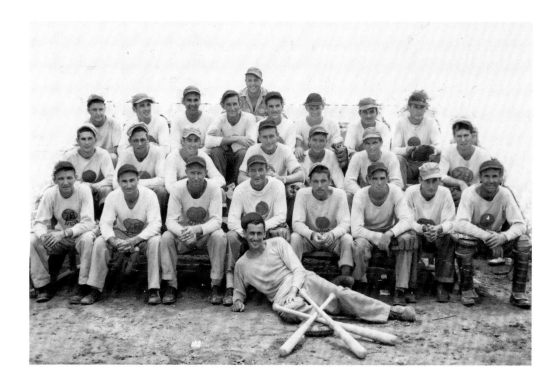

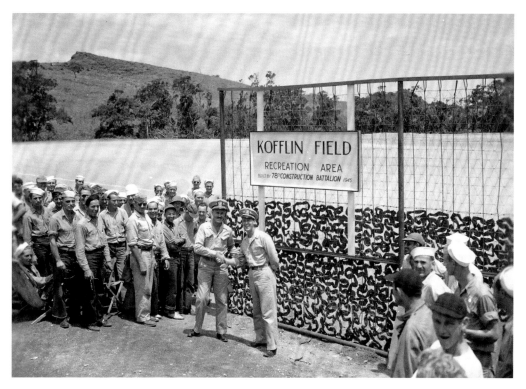

No one was fooled by the relatively light schedule and lightened mood on New Caledonia. The men all knew that soon orders would come and the battalion would be moving on, to another Island X. To keep sailors fit and healthy, officers organized swimming lessons. Although they were members of the US Navy, many of the welders, stevedores, carpenters, and mechanics of the construction battalions had limited experience with swimming, sailing, rowing, and water sports.

During this time Nat painted

TARGET

May 2, 1945
Leave Nouméa, SILENT CONVOY
New Caledonia June 17, 1945
 CONVOY NORTH Arrive Okinawa

1945

CHAPTER

6

UNDERWAY: ABOARD
THE USS *J. FRANKLIN BELL*

In late April the orders finally came. The 78th Construction Battalion would be moving out to yet another Island X. Although there was never an official acknowledgment, Nat knew exactly where the 78th was headed. They all did.

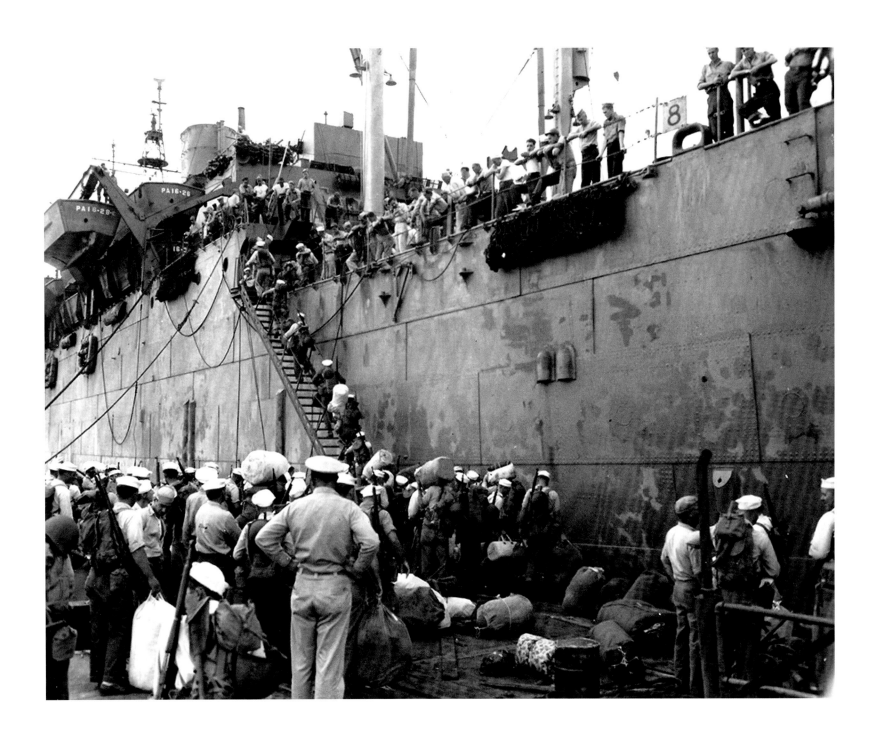

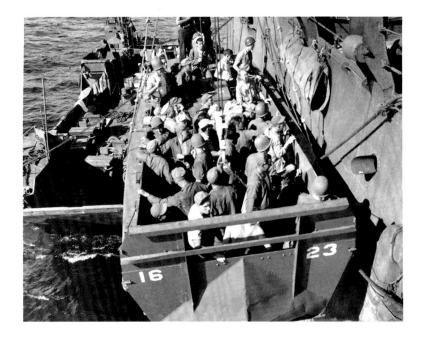

As the 78th construction battalion scrambled aboard the *Franklin Bell*, there was a sense of restless energy in the air. After five months of working at a pace that had fallen into easy routine, the men were once again filled with both eagerness and dread. Determined since the beginning to do all they could to help win the war, every man knew they would never reach that goal without a long, tough, dangerous, and exhausting stint on one last Island X. They would need to build the massive base that would take the war to its inevitable final end point—the base that would enable fighting men to launch an invasion of the Japanese home island. They were headed for Okinawa, where ferocious fighting was already underway.

TARGET

The progress of the *Franklin Bell* to the battalion's next destination was painfully slow. The Seabees laid over in the Eniwetok atoll in the Marshall Islands for several days. From there they cruised to the Ulithi atoll in the Carolines, where the ship was anchored for nearly three weeks. Here, hundreds of ships were gathering. Here, too, each sailor was allowed one or two days on Mog Mog Island, the Pacific Fleet's rest center, which offered four kinds of entertainment: baseball, boxing, beaches, and beer (two cans for each sailor).

When the *Bell* finally got underway, it was part of a massive convoy—ships nearly countless in number, all traveling in the same direction, all proceeding under orders of extreme caution. The goal was to be invisible from a distance. On each ship, one man was always assigned to watch the stacks, to make certain that the smoke being emitted was clear. Even so, the men assigned to stand by the antiaircraft guns were always on full alert.

Every time Nat was on deck, his eyes first scanned the horizon, then instinctively turned to glance up to the forward turret. The men who stood in that turret were grim-faced, tense, poised for action. And always, *always*, all three were looking up.

The gun turret looked solid, secure, even invincible. The men looked serious. They were watchful and determined. The steely blue-gray of their station, its ladder, and its support struts blended with the sky, just as the entire ship blended with the vast ocean through which it sliced its way swiftly and silently.

Each time a lookout pointed skyward, someone on deck noticed, nudged others, and soon everyone was looking up. Every man aboard knew the danger. Since last October, the Japanese had been employing a new and incredibly gruesome human weapon: the kamikaze special attack force—several thousand converted or specially built aircraft, crammed with explosives. Severely damaging an Allied ship, especially an aircraft carrier, was considered a reasonable exchange for the life of a minimally trained young man and the loss of a plane that was useful for nothing better. Causing as much destruction as possible was the goal.

As Nat watched the men who were guarding the ship, he noticed a change in the light in the sky. The sunlight, bouncing off high cumulus clouds, seemed to bathe the three helmeted men in a pale golden glow—the lookout pointing skyward, gunners poised and ready. It was a friendly glow. A protective glow. And suddenly, Nat knew—not wished, but knew—that whatever the lookout was pointing to was not a threat to this ship. They were all safe . . . at least for now.

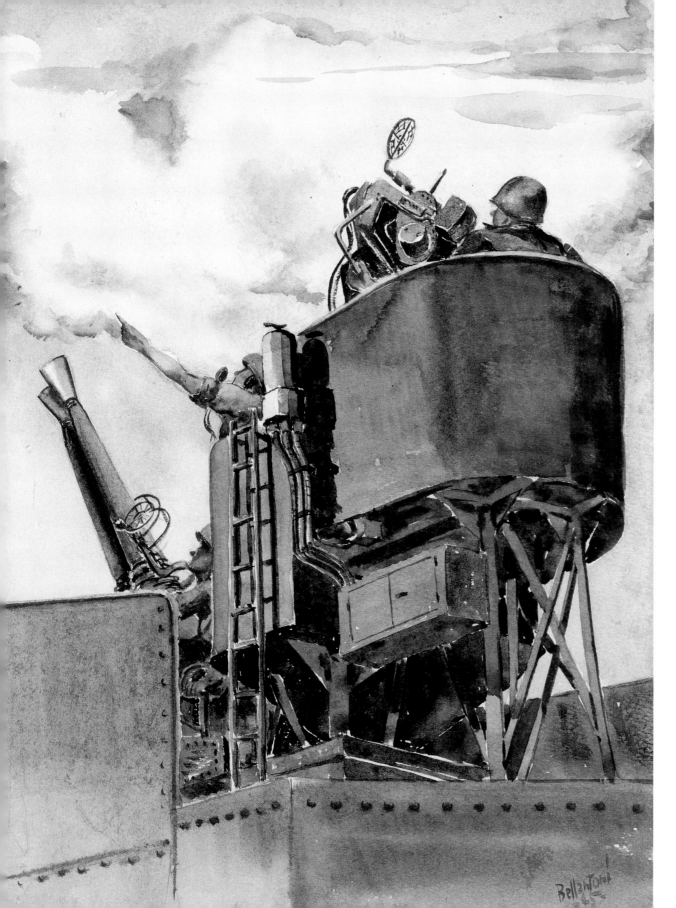

Target, painted aboard the
USS *J. Franklin Bell*, 1945.

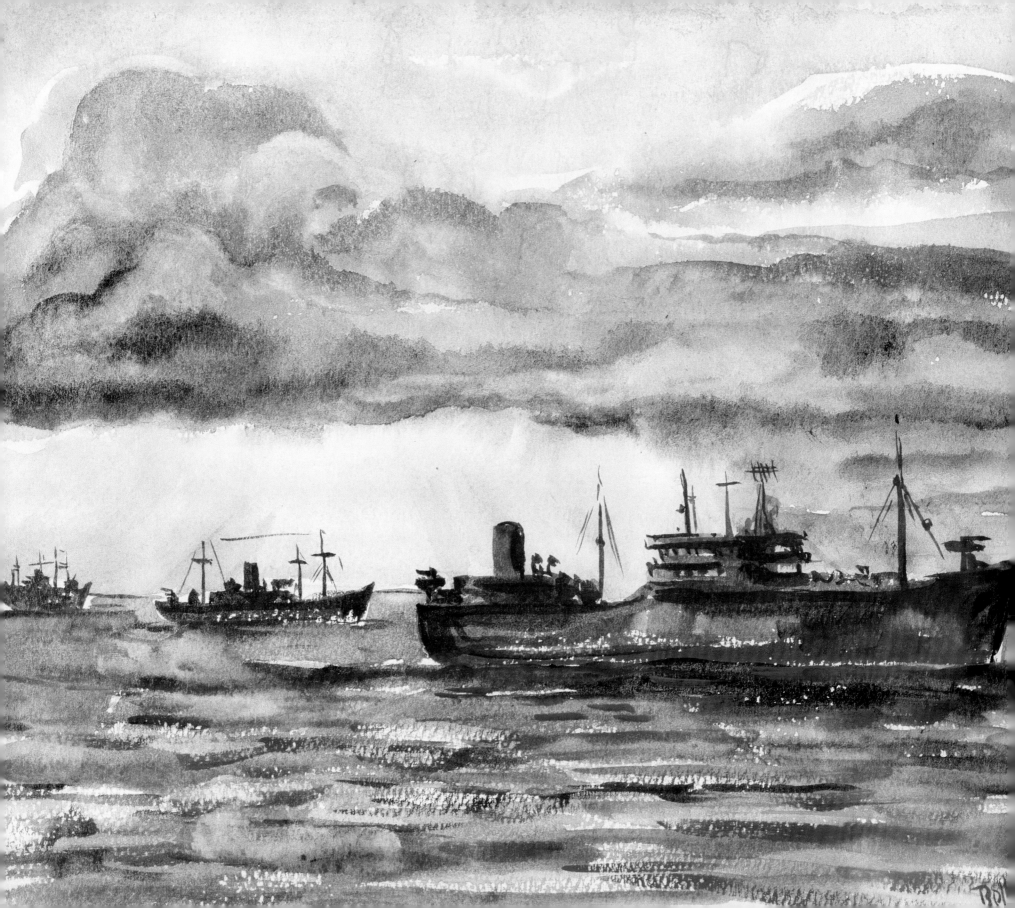

SILENT CONVOY

The sea and the sky offered vast possibilities for sabotage or surprise attack. Yet the sea and sky also offered endless opportunities for solace and inspiration.

Nat was restless. *Sometimes, the beauty of nature's irrepressible perfection can take your breath away—usually when you least expect it.* This is what he was thinking as he stood at the gunwale of the *Franklin Bell* on an early June morning.

As the sun crept over the horizon in a bursting glow of buttery yellow, it churned the eastern sky into the warmest possible mix of colors. Those colors reminded him of summer fruits—peaches, plums, and berries.

The ship was bathed in the silence of an uneventful dawn. Like all the other ships in this vast convoy, the *Bell* was at anchor. Except for those on watch, most of the men on board were still asleep. Most of the men on the other anchored ships whose silhouettes were etched darkly against the brightening sky were no doubt sleeping, too.

But Nat was wide awake. It had been a restless night. This was a restless interval. There was too much time to think and not enough to do. He took note of the darkening clouds gathering overhead. Bursting up to meet them, the rays of the rising sun now looked like sheets of fire. The scene was not so tranquil anymore. Maybe Mother Nature was restless, too.

Silent convoy, painted aboard the USS *J. Franklin Bell*, 1945.

CONVOY NORTH

For as far as the eye could see in every direction, the surface of the ocean was dotted with the sturdy profiles of formidable ships: ships of all sizes, all types, all descriptions—cruisers, destroyers, battleships, and others like the *Bell*, a purpose-built attack transport. All traveled in a grim, blue-gray procession over a grim, blue-gray sea. All were headed in the same direction: north. There was no question this time about their destination. The men knew the name of their last remaining Island X: Okinawa.

This island, a few hundred miles south of mainland Japan, was now embroiled in the most intense, ugly, cruel, inhuman fighting of all the battles that had taken place across the Pacific these past three and a half years. In those forty-two months, how many brave young men had faced—or faced down—death? How many had suffered hideous wounds? How many had been lost, their fate and final resting places unknown? And how many more would have to fight, suffer, and die?

Nat could not push back these thoughts as he stood, once again, on the deck of a ship taking him to yet another assignment. His part in all this had been different from so many others. He had been asked to create rather than destroy. For this he felt grateful, but also a little bit guilty. He had never been required to crawl onto beaches or run through curtains of machine gun fire.

Now the war in Europe was over. On May 7 the Germans had finally surrendered. Hitler was dead. American forces were in Berlin. The shipboard announcement of victory in Europe had been made on May 8. It was wonderful. The men had cheered, jumped up and down, hugged one another, thrown their white Dixie-cup hats up in the air. Then, as they leaned over to pick up the hats that carpeted the deck, they stopped their happy shouting as suddenly as they had started. When would it end *here*?

Nat looked at the sky. It was solidly overcast. It would probably rain a little later. Somehow he felt comforted by the softness of those clouds. The slightest pink tone gave them a hint of warmth.

His focus shifted to what was close at hand. Just overhead was one of the ship's lifeboats. It was a good-sized lifeboat, yet compared to the ship itself, it was a tiny, fragile thing. Over all these months of sea battles, many sailors had found themselves suddenly cast into this vast ocean. The lucky ones had a small boat like this; some, just a life jacket. Others had nothing at all between them and the deep, dark waters of the Pacific.

Nat thought of the simple prayer that never failed to give him a sense of safety and peace. He didn't know why, as it offered no guarantee. It was the Breton Fisherman's Prayer. Admiral Hyman Rickover had made it famous by presenting to every new submarine captain a wedge-shaped wooden block emblazoned with its words: *O, God, Thy sea is so great and my boat is so small.*

Convoy north, painted aboard the USS *J. Franklin Bell*, 1945.

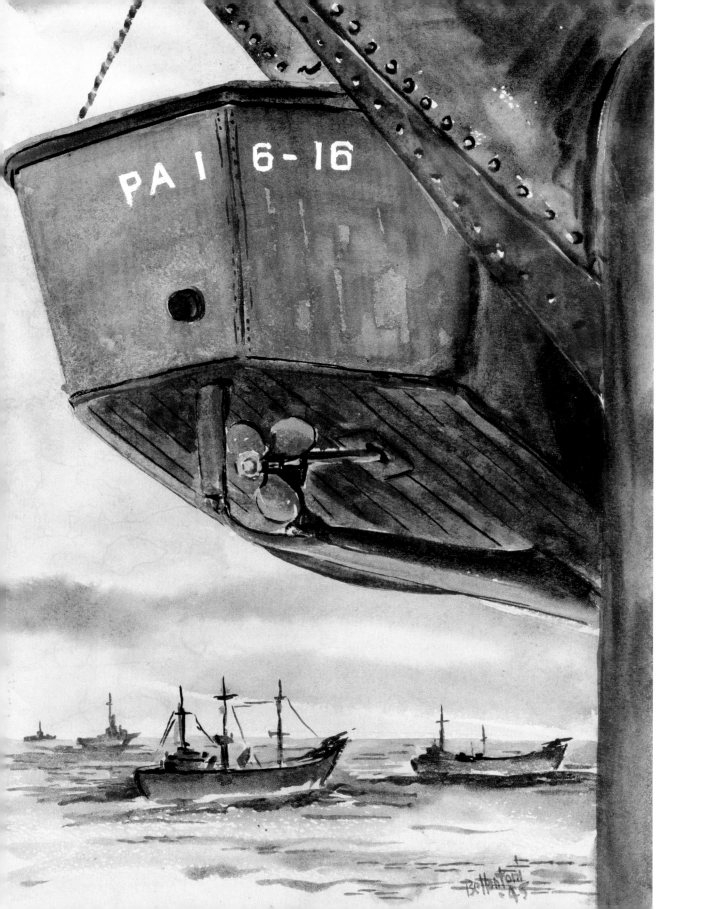

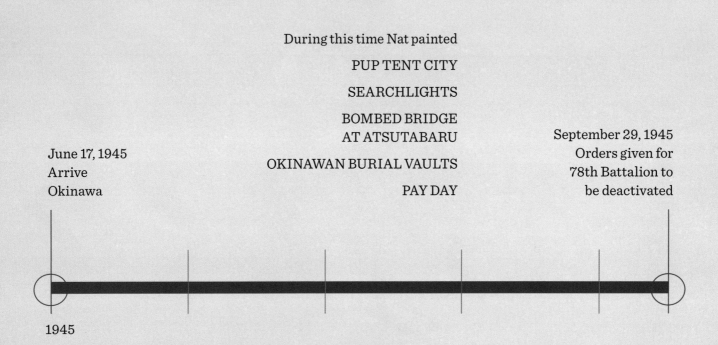

June 17, 1945
Arrive
Okinawa

During this time Nat painted

PUP TENT CITY

SEARCHLIGHTS

BOMBED BRIDGE
AT ATSUTABARU

OKINAWAN BURIAL VAULTS

PAY DAY

September 29, 1945
Orders given for
78th Battalion to
be deactivated

1945

OKINAWA, RYUKYU ISLANDS OF JAPAN

═══════

THE ULTIMATE ISLAND X

The 78th Battalion was aboard the *Bell* for six full weeks. The war news came to them in fragments: the US Sixth Army, fighting its way across the Philippines; the Japanese carrier fleet pummeled nearly to oblivion, leaving fighting men still scattered across the Pacific but with no source of resupply or transport; the bloody battle for Iwo Jima back in February and March, victory at a hideous, haunting price. The men had heard about the sinking of the *Yamato*, Japan's great battleship, and the death of President Roosevelt, who had led the country to the very brink of victory and yet would never see it. American B-29 bombers were now within striking distance of Japan. Yet the Japanese fought on.

The road from Pearl Harbor to the Japanese home islands was almost complete. It had been built by the unflagging valor of America's fighting men—soldiers, Marines, fliers, sailors, and submariners; by the know-how and hard work of Navy Seabees and Army engineers; by the skill of code breakers and code talkers. It was built by the heroism of corpsmen, doctors, and nurses; the leadership of US officers and officials; the industry of American workers, who had simply out-manufactured the enemy; and the devotion of families at home, who watched, waited, and prayed.

Now, the very last section of that road—the staging ground for the last great battle—was the island of Okinawa, just a few hundred nautical miles southwest of the southernmost Japanese home island. This would be the 78th's last Island X.

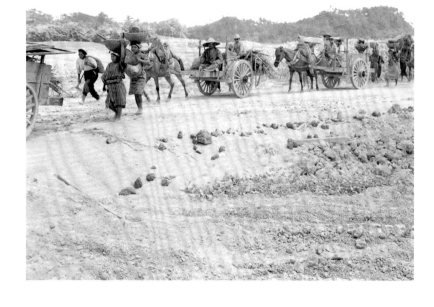

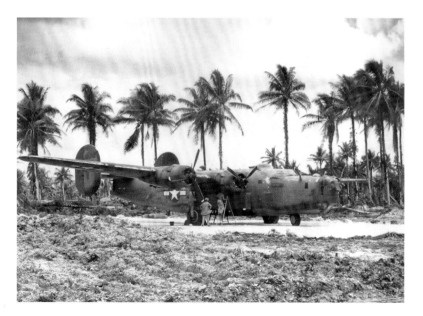

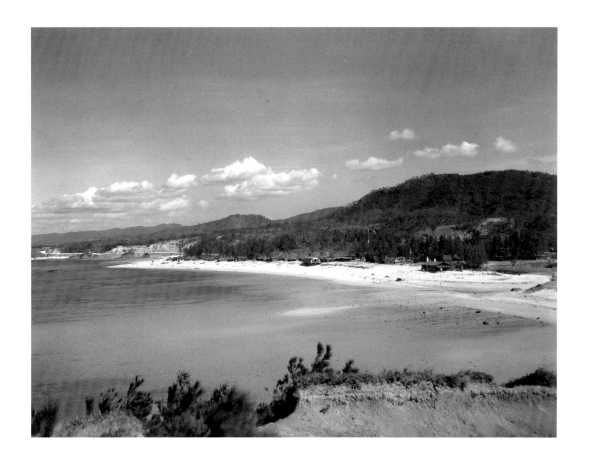

These photographs were all taken on Okinawa. Color film was still in its infancy, so color shots from World War II are rare.

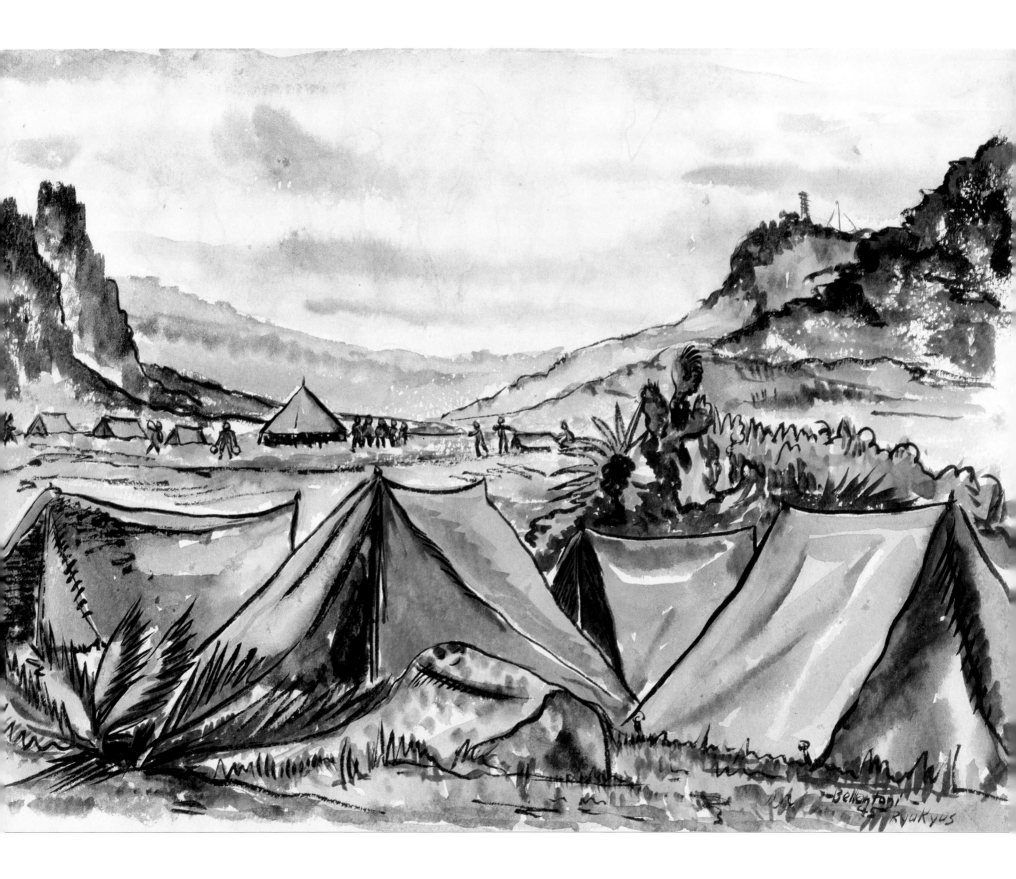

PUP TENT CITY

For Nat, there was always an optimistic, hopeful feeling that came with pitching a tent and setting up a new campsite—as a young Boy Scout, as a teenager adventuring with his uncle and cousins in New Hampshire, and even here, where a terrible battle was still going on far to the south. The US Navy's 78th Construction Battalion had finally come ashore on Okinawa under a smoke screen laid down to protect the ship, the men, and their precious store of equipment and supplies.

Nat pushed aside thoughts of strafing machine gun bullets, killer bombs, and kamikazes. It was a relief to be freed from six weeks of shipboard confinement . . . to be drinking in a scene of wide vistas, green hillsides, rocky crags, and abundant stands of shrubbery, ferns, and exotic tropical plants . . . to know that days of idleness were over. There was work now for the 78th to do. Now the men could throw themselves into their projects, knowing that every foot of paving they laid down, every structure they put up, every fuel and water tank they built would be a step toward ending this endless war.

Their first task was to raise their pup tents. They would be sleeping on the ground again. But so what? What the hell! The ground was relatively dry. Soon the few tents on this open field would be multiplied by hundreds. They'd be calling this wide expanse of flat terrain Pup Tent City. They would also call it home. Nat stood for a minute casting his eye over his tiny tent neighborhood—not yet a city. The sky in the distance suggested rain, yet there was also a definite, unmistakable brightening. The entire scene seemed to be speaking to him. He wondered for a while what it was trying to say. He searched his mind for the right word. And then he realized that he knew. The word was "hope."

Pup Tent City, painted in Okinawa, 1945.

SEARCHLIGHTS

There was no pretending the war was any place else but on this island, thanks to the constant, assertive drone of planes overhead—the roar of bombers on night missions, the zip of fighters, and, occasionally, the high distant buzz of the enemy. Some nights Nat would lie awake, sleepless, listening. Then finally, with a sigh, he'd roll over, peer through the open tent flap, and watch the man on watch, watching the sky. Most nights there would be nothing to see but the blue-black sky and a million twinkling stars.

Some nights, however, the air raid sirens would sound. The men would all scramble into their foxholes, and the sky would be awash with brightness—brightness that suddenly turned the middle of the night into twilight, brightness striped by the wide, white beams of a dozen powerful searchlights. The lights came on suddenly, sometimes all at once, sometimes one by one. These brilliant lights, manned all night long, encircled the base like protective, watching eyes. As soon as they were turned on, they roamed the sky in graceful arcs like the twitching, questing stare of an alert owl—hunting in the dark.

Once a light found its prey, its roving stopped. That searchlight held the intruding target in its inescapable beam. Then one by one, all nearby lights would zero in on the very same spot—the very same target. All those light beams, coming from different positions on the ground, converged on the exact same point in the sky. And as the target moved, they moved with it—slowly—holding it in their grip. The pattern of those lights against the sky took the shape of a lady's fan, held upside down (perhaps a geisha's fan). Nat thought about the geometric patterns embroidered with smooth white stitches on the blue quilt on his bed at home; square after square of fan-shaped stitches. He always felt warm and safe under that blue quilt.

Suddenly, at the focal point of all that white stitching, the base of the fan, the sky erupted in a burst of flame. Antiaircraft guns had found the target, a Japanese reconnaissance plane. For a moment, the brightness looked like more embroidery stitches—red, yellow, orange. French knots, he thought they were called. He had watched his Nonna make them, clusters of them, in the center of embroidered flowers. The "all clear" sounded and Nat crawled back into his tent. He almost laughed at himself. He shook his head, rolled over, closed his eyes, and sighed. He was ready to get some sleep.

Those searchlights in the sky: a protective quilt? That was just a ridiculous fantasy. Wasn't it?

Searchlights, painted in Okinawa, 1945.

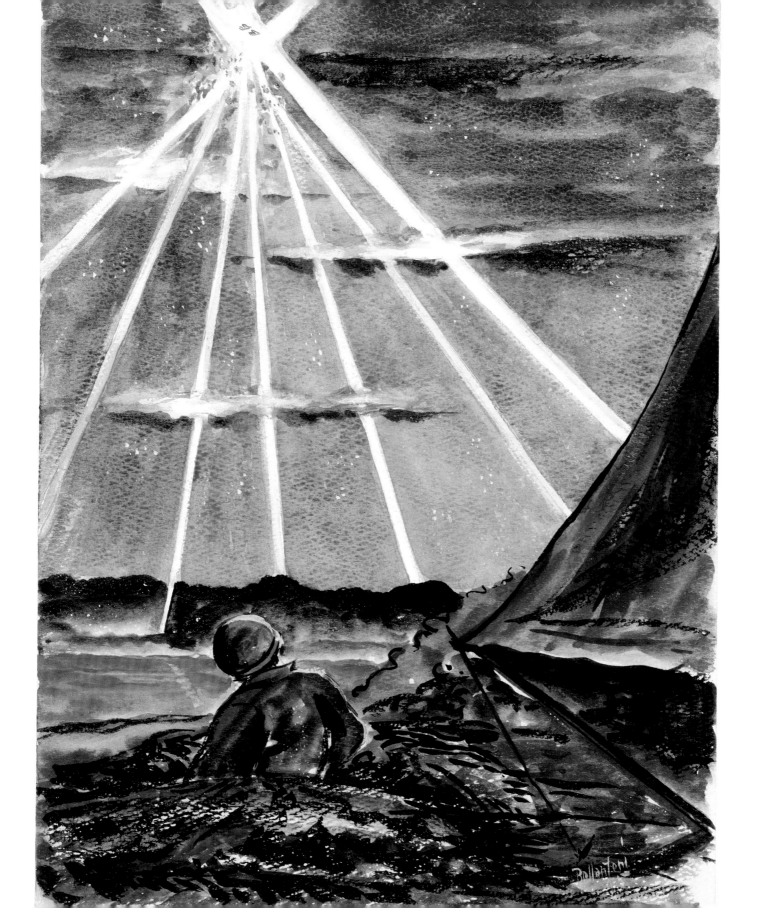

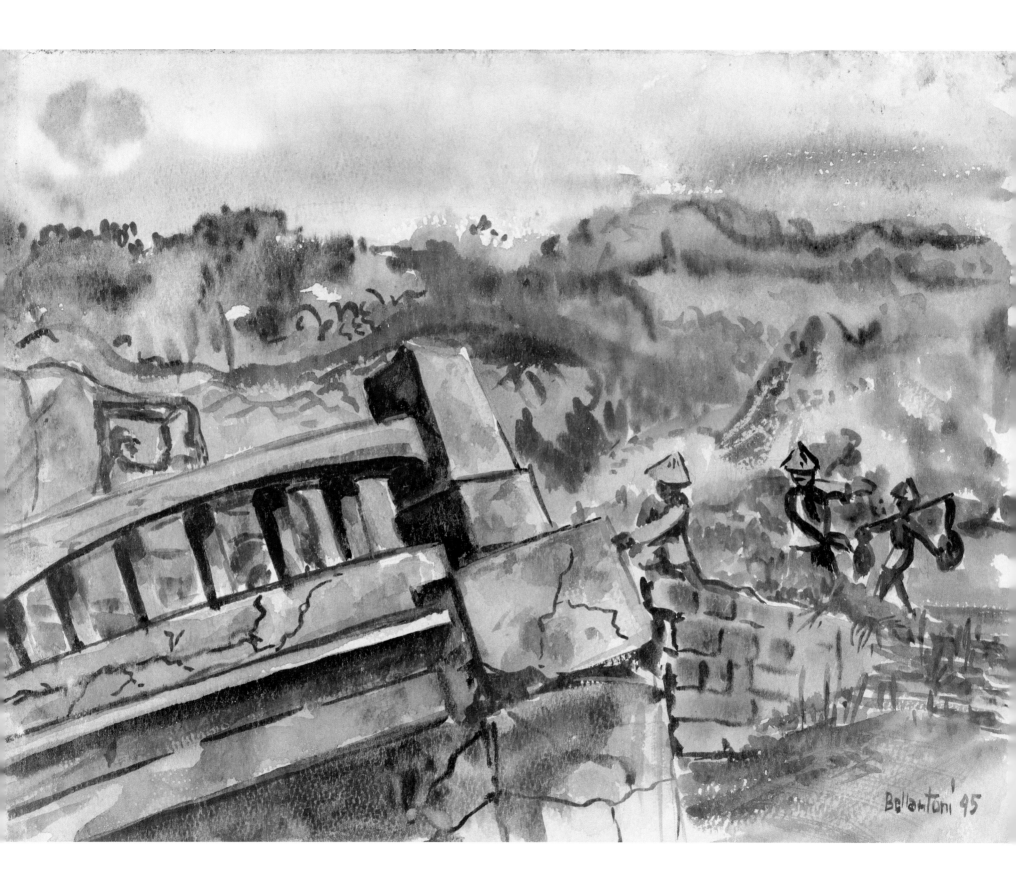

BOMBED BRIDGE AT ATSUTABARU

There was so much energy and urgency in the early mornings on this island of contrasts and contradictions. As Nat started to organize himself for a busy day, he stood for a moment and watched the scene unfolding before him. He was struck by the odd juxtaposition of the familiar and the exotic. Uniformed Americans hurried in one direction; Okinawans in their traditional garb rushed in the other.

The trucks, loaded with water, rations, ammunition, and medical supplies, were bound for the front lines where Marines were at this very moment struggling, striving, fighting, and dying. The islanders were carrying supplies also—rice, meat, medicines—to the men of the island who were interned in camps nearby.

The damaged bridge at Atsutabaru was riddled with jagged cracks. Yet the weather-worn retaining wall supporting the road that approached it was solid and intact. The drabness of everything man-made—the bridge, the wall, the truck—looked out of place against the riotous colors of nature: green and gold grasses on the hillside, the trees that stood blue in the morning light, and the sky itself, tinted all shades of mauve and pink as the sun fought its way through thick layers of clouds.

Nat was grateful that this was his place, his spot, his assignment: well behind the lines. Not that the war hadn't touched this part of the island. The war, it seemed, had touched every part of every island. He could do nothing to stop it, nothing to make it end sooner . . . nothing except do whatever it was he was asked to do. That was his duty. That was his commitment. He would do much more if only he could. But his only choice was to do his job and wait for this war to stop.

What was the last line of that famous poem? The one he had to memorize back in high school? *They also serve who only stand and wait.*

Bombed bridge at Atsutabaru, painted in Okinawa, 1945.

OKINAWAN BURIAL VAULTS

Nat found himself fascinated by Okinawa's *kameko-baka*, the turtle-back tombs. Each had a domed roof encircled by an omega-shaped ridgeline, and in front a small doorway and walled courtyard or lawn. They seemed to be built into every hillside, tucked into every ravine. Some were carved from limestone outcroppings; others were built of quarried stone. The newer ones were made of concrete. Their cool, silent interiors housed urns that held the bones of venerated ancestors. Most were family tombs, large enough to accommodate the remains of many generations. Others, much bigger, could hold up to a thousand urns—the ashes of all the ancestors from an entire village.

When war came, many terrified civilians took refuge in their families' tombs, where they huddled together, sharing whatever food and water they had managed to carry with them. In the south, the Japanese army had tossed out the urns, scattering ancestral bones, so they could turn these sacred structures into gun emplacements.

Nat came across a pair of *kameko-baka* guarded by stately conifers. Fronting a field that was golden and green, they seemed to fill an entire hillock. The scene was freshly washed from rains that had ceased just moments before. The tombs with their squat, square doorways looked to Nat like a pair of eyes, wide and watchful.

You people out there, the ancestors inside seemed to be asking, *what have you done to these innocent people—our children, our grandchildren, our great-grandchildren? They are simple people, just farmers. They did not ask for war. They had no wish to conquer anyone or to fight, only to care for their fields, their crops, their livestock. Yet you have killed so many. Those still alive are hungry, homeless, frightened. Even us, the old ones, the dead ones. Many of us are homeless, too. Our peaceful resting places ruined . . . desecrated. Why? What have you gained from all this destruction? When will men learn that nothing is ever gained from warfare? Only loss. Loss and suffering. When will you go away so our people can go back to their peaceful lives? And we can return to the peace of death?*

Nat had no answers.

Okinawan burial vaults, painted in Okinawa, 1945.

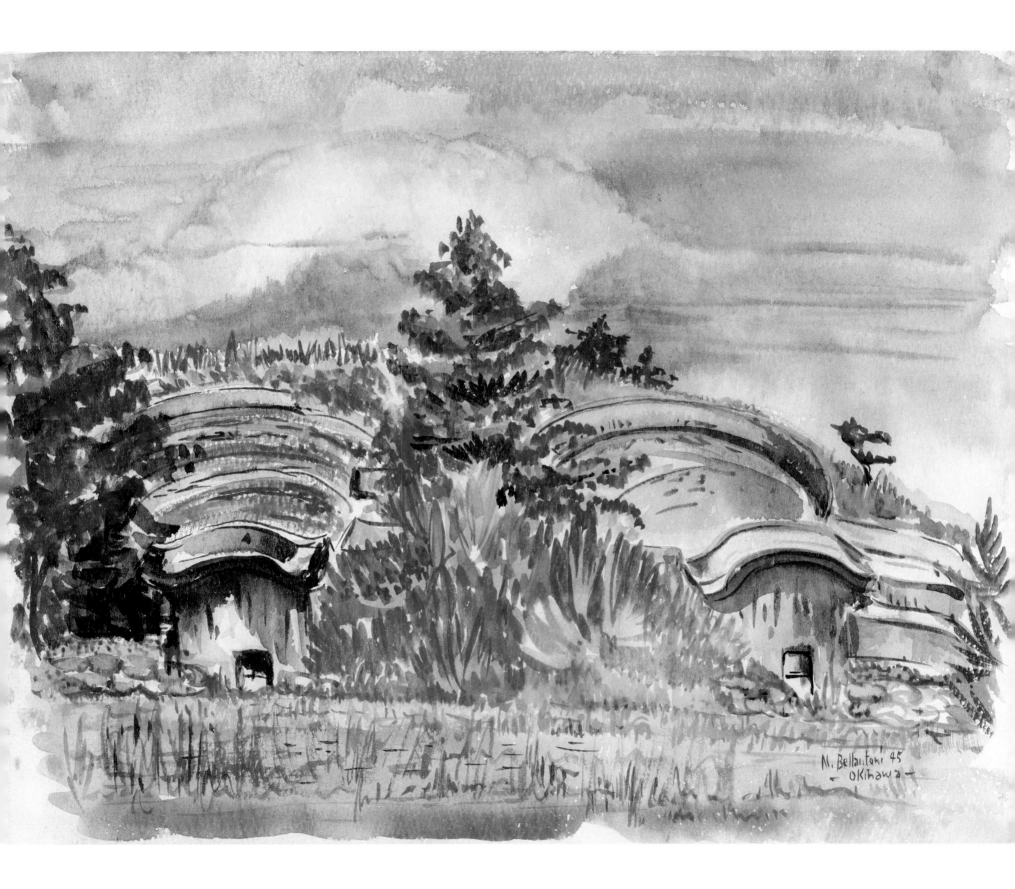

N. Bellantoni 45
— Okinawa —

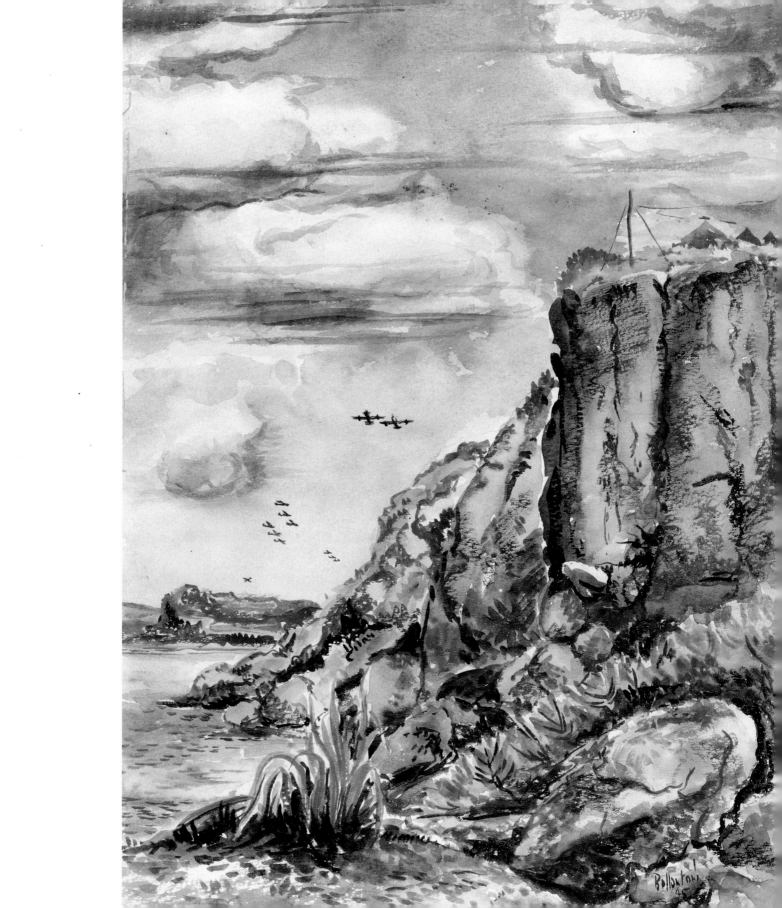

PAY DAY

Nat felt a sharp pang of pride, mixed with both grief and relief, each time a squadron of B-29s soared overhead, flying due north. Sometimes there were only a few. Sometimes, as on this morning, they roared over by the dozens. They looked invincible, these powerful silver ships of the sky. But of course they were not. Nat knew it, and the men flying them knew it. They all flew off bravely. But often, all did not return.

Just a few moments earlier, he had been studying this slice of the island's arresting natural beauty: steep chalky cliffs, tumbling greenery, cascading rock formations, bordering a vast plain dotted with verdant plateaus. Those plains just a few months earlier had been crisscrossed with farmers' fields and patches of wildflowers and grasses. Now they sprouted fuel tank farms and row upon row of tents, assorted new buildings, communities of trucks and construction equipment. Even so, sometimes, it was possible to come upon views like this, where all the changes brought by war could be blocked out and the island could assert its ancient and perpetual uniqueness.

Then came the planes. The airmen flying them were striving to end the war. It wasn't easy. The enemy was clearly defeated, yet would not quit. Fight to the death: that was their culture, their conviction, their commitment. The Americans did not want to fight to the death. Nat certainly did not want to fight to the death. He wanted to stop fighting. He wanted to live. They all did. How ironic that the only way they could stop the war and live was to keep killing and risk dying.

That's where these planes were going: to bomb Japan's home islands. It was the goal they had been inching toward for so long. That was the reason so many young soldiers and Marines had died on so many islands: to get close enough that they could bring the fight to the homeland. Maybe then the Japanese would quit.

This war in the Pacific had started with planes from the north flying south to drop bombs on Americans. It would end with planes from the south flying north to drop bombs on the Japanese. It wasn't revenge. But it was necessary. It would not bring back those young men. Yet it felt, in some ways, like payback—not vengeful, but avenging.

The day had started out sunny. But now the fluffy cumulus clouds had taken on an ominous darkness. They looked angry—glowering, scowling. Nat realized, suddenly, that he was scowling, too. His brow was deeply furrowed. He gave himself a shake. He could not afford to think like this. He had to turn his attention to the task at hand. He had to get his day started, do his work.

What choice did he have?

Pay day, painted in Okinawa, 1945.

8

FINALLY,
IT WAS OVER

At 2:45 a.m. on August 6, 1945, the B-29 Superfortress *Enola Gay* lifted off from North Field, Tinian Island. Five hours later, with Hiroshima's Aioi Bridge aligned in the crosshairs of his Norden bombsight, the plane's bombardier released its unimaginable payload, the first atomic bomb ever exploded over a populated city. The world would never be the same.

This is a Jap bomber called a Betty - it carried the delegates who flew to Manila to receive the peace instructions. Ed took this on Ie Shima, it was on a Sunday afternoon.
Okinawa

IE SHIMA

Nat and the 78th's photographer Ed Keegan were sent to this tiny island off the coast of Okinawa in the East China Sea to witness and document the landing of the emissaries from Japan who were transferred to US planes which would take them on to Manila for the surrender ceremonies aboard USS *Missouri*.

These leaflets were dropped by the thousands behind Japanese lines. Printed in both English and Japanese, they encouraged Japanese soldiers to surrender, assuring them safe passage and humane treatment.

On August 9, a second atomic bomb was dropped on the city of Nagasaki. And the Soviet Union, having declared war on Japan the day before, invaded Japanese-held territories in Mongolia, Korea, and several North Pacific islands.

On August 15, in a radio broadcast marking the first time he had ever spoken directly to his subjects, Emperor Hirohito announced Japan's acceptance of the Allies' demand for unconditional surrender.

Japan's war had cost nearly 20 million Asian lives, more than 3.1 million Japanese lives, and more than sixty thousand Western Allied lives. Finally, it was over.

HEADING HOME

At long last, Nat and the men of the 78th Construction Battalion were heading home, with seabags on their shoulders and pride in their hearts. Their achievements were now a part of history.

Over the previous three and a half years, the US Navy's Seabees had constructed 111 major airstrips, 441 piers, over 2,500 ammunition magazines, hospital capacity for 70,000 patients, 700 square blocks of warehouses, housing for 1.5 million troops, and storage tanks holding 100 million gallons of gasoline. The Seabees in total built more than four hundred bases. Eighteen were major facilities constructed at a cost of more than $10 million each (in World War II–era dollars). Fifteen of the eighteen were in the Pacific theater; of these, twelve were in strategically crucial locations that had to be wrested from the enemy. This meant that mountains of rubble—the debris of battle—had to be cleared away before building could begin.

The Seabee motto was, and remains, *We build. We fight.* Their slogan is "Can do!" It is no exaggeration when considering the history of World War II to say that the Seabees truly built America's victory.

Nat Bellantoni would ever after be proud that he had been one of them.

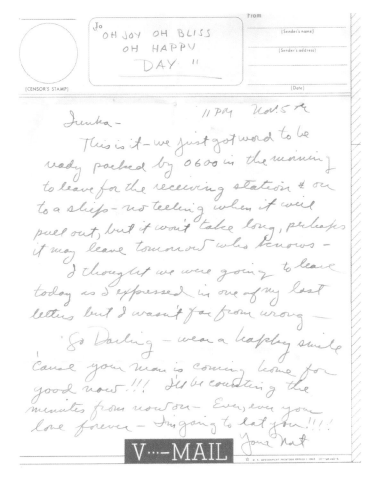

To OH JOY OH BLISS OH HAPPY DAY !!

11 PM Nov. 5 ᵈᵉ

Junka –

This is it – we just got word to be ready packed by 0600 in the morning to leave for the receiving station & on to a ship – no telling when it will pull out, but it won't take long, perhaps it may leave tomorrow who knows –

I thought we were going to leave today as I expressed in one of my last letters but I wasn't far from wrong –

So Darling – wear a happy smile 'cause your man is coming home for good now !!! I'll be counting the minutes from now on – Ever, ever your love forever – I'm going to eat you !!!!

Your Nat

V····MAIL

At war's end, the US military's War Shipping Administration launched "Operation Magic Carpet," the massive, world-wide undertaking that would transport nearly eight million military personnel home from overseas locations. Aboard ships headed to American shores the mood was ebullient, despite cramped conditions. This light-hearted spirit was reflected in the daily newsletter distributed to home-going personnel aboard the USS *Admiral H. T. Mayo*. This issue, from September 21, 1945, features news of the Japanese surrender in Singapore, an article celebrating generous shipboard rations, baseball scores, and plans for onboard variety shows. The banner headline "Quisling Gets It!" proclaimed the conviction and death sentence of the hated Norwegian military officer and politician Vidkun Quisling, who headed the government of Norway during the war, collaborated with Nazi occupation, and willingly participated in Germany's Final Solution. His name has ever after been a synonym for traitor.

TO THE NAVY, IT WAS THE NAVAL SEPARATION CENTER

To Nat, it was so much more . . . an end and a beginning . . . a place where all his fears and sorrows of the past three years collided with all his optimism and anticipation for the future. Among these long, shuffling lines of sailors-soon-to-be-civilians were a few Nat knew from his unit, some he recognized from his weeks of basic training a lifetime ago. Many had stories they were eager to tell. Others were silent. All waited their turn at the various stations where their papers would be signed and stamped and they would be free, finally, and could head home safe and alive.

Nat took a very deep breath and let out a huge sigh. He laughed a little to himself. It was only now, he realized, that in some sense—not physically but mentally—he had been holding his breath all these long, long months.

He let his thoughts ramble freely, unchecked, as he stared up at the lights, huge arcs of metal and mesh hanging from industrial-strength chains in the noisily echoing room. Nat recalled what he had known of war before he actually experienced war. It was true, just as Shakespeare said in *Henry V*: men who fought together became a band of brothers. Nat certainly felt that sense of brotherhood with his fellow Seabees and knew he always would.

Yet warfare, as it was portrayed in literature, Nat thought, whether Shakespeare or Scott or Tennyson . . . that was fantasy. It was in history classes where the futile and ironic truth was taught. It happened over and over. An arrogant, overconfident egoist—Alexander, Genghis, Caesar, Napoleon—decided that he should conquer, subjugate, defeat his neighbors. Or a passionate, overconfident contingent of citizens decided that governance should be changed by force. Whatever the ambition or the cause, the result was never the one anticipated. Wars, once started, are never over quickly. No, they drag on for years, or decades, or centuries. Inevitably, the conqueror would overreach, the invader would be turned back. And the armies would be sprawled, contorted in death, surrounded by destruction . . . defeated. So it had been in the wars Nat learned about in high school. So it had been in this one. Hitler and Mussolini: dead. Hirohito and his generals: disgraced. And tens of millions of souls: lost. Nat recalled another line from Shakespeare that applied to the stupidity of men who started wars: *What fools these mortals be!*

Bellantoni! Bellantoni!

Nat heard his name. He shook himself back to the here and now. It was time to step forward. Within moments he had the precious paper in his hands: honorable discharge. It was stamped. It was signed. Now he could breathe freely. He could plan for the future. Just four days ago—still an active-duty Seabee—he had married Irene. He would get a job. He was going to be an artist. He was going to have a life. And he was going to enjoy every moment of it.

It was time to go home.

AFTERWORD

———

A DREAM FULFILLED

Nat Bellantoni was discharged from the US Navy on January 10, 1946, having spent some time in sick bay (as did many of the men who had come home from the Pacific, still coping with the vestiges of various tropical illnesses). He had served on active duty for three years, three months, and three days.

On January 6, 1946, four days before his discharge from the Navy, Nat had married Irene Sztucinski, whose love and letters had sustained him throughout his long months on New Caledonia, New Guinea, Manus, Los Negros, and Okinawa.

Together, Nat and Irene settled down in Reading, Massachusetts. They raised three children: Stephen, born in 1947; David, in 1949; and Nancy, in 1954.

For more than thirty years, Nat worked as a professional artist and graphic designer. Although he went straight to work rather than finishing art school, he was awarded an honorary degree from Mass Art many years later.

For most of his career, Nat worked at Gunn Studios, a renowned graphic design firm on Newbury Street in Boston. Bill Gunn and his wife, Mary, had been classmates of Nat and Irene at Mass Art. Like Nat, Bill had left school to join the war effort. He served in the US Marine Corps and lost a leg on Cape Gloucester, New Britain. Nat, Bill, and all the men of their generation who served in the war had experiences they would never forget, stories they would—and would not—tell. Some, like Bill, came back with severe injuries that would mark them as war veterans for the rest of their lives. Others, like Nat, showed no visible signs of injury or trauma. Yet all were changed.

All were heroes.

REQUIESCAT IN PACE

Although he always remained an artist, Nat never again painted with the passion, intensity, and sense of purpose that had marked his work while he was serving as a Seabee in the South Pacific. During that time it was the sketchbooks, the art paper, the pencils, and the watercolors he had packed in his seabag so carefully that had sustained his spirit and enabled him to survive.

Nat Bellantoni died on June 23, 2012. He was buried with full military honors—a Seabee to the end.

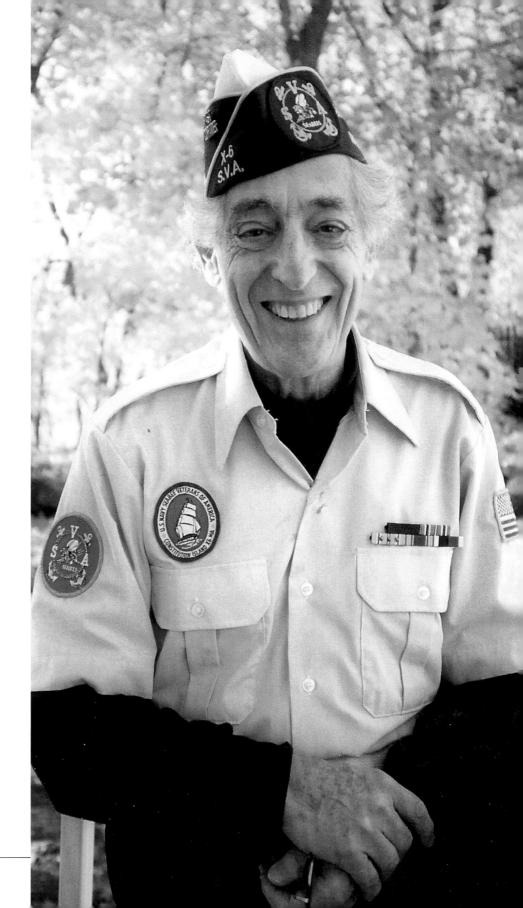

ABOUT THE ILLUSTRATOR

───

Natale Bellantoni was born on December 21, 1920, into a large and loving family of Italian immigrants in Boston's South End. Two decades later, he found his plans to become an artist derailed by the cataclysm of World War II. Instead of finishing his studies at Massachusetts School of Art and launching a career as a commercial artist, he found himself in the South Pacific, assigned to the United States Navy's 78th Construction Battalion. Nat lived and worked on several islands; his longest assignment was in the Admiralties, amid jungle heat and humidity, bugs and snakes, tropical diseases, monsoon rains, and local populations that only recently had practiced headhunting.

Always gregarious, with a ready smile and genuine interest in the people and events around him, Nat made it his mission to document his experiences. He sketched, he painted, and he saved the flotsam and jetsam of his sojourn.

Once the war was won, Nat returned home, eager to resume the life he had left behind three years earlier. He married his sweetheart, raised a family, and had a successful career as an art director in a prestigious downtown Boston firm. His boxes of wartime memorabilia were stored away, seemingly forgotten, as the decades passed. Now, with his children grown and his mortgage paid, Nat began to reconnect with old friends and old memories. At age 91, he dreamed of sharing his wartime story. This book is the fulfillment of that dream.

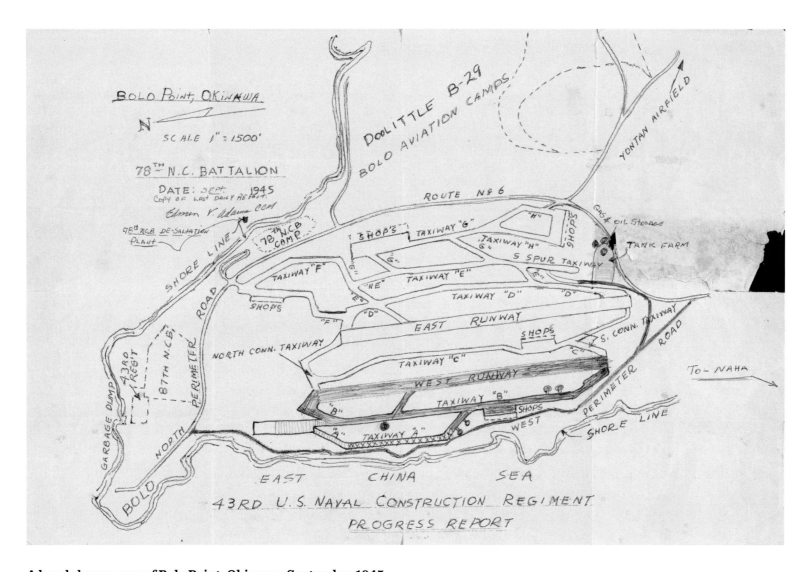

A hand-drawn map of Bolo Point, Okinawa, September 1945

Just one of the many thousands created and used to guide and document projects, many of them massive in scale. This map of the airfield at Bolo Point, on Okinawa's East China Sea coast, illustrates the crucial role the naval construction battalions continued to fulfill even after the Japanese surrender on August 15, 1945. The airfield, originally built by the Japanese but captured and rebuilt after the United States seized it during the Battle of Okinawa, stationed American B-29 Superfortress bombers. After Japanese surrender, the facilities at Bolo Point were used to store surplus tanks, trucks, and bulldozers. This equipment would later be sent to Korea for use during the Korean War.

ABOUT THE CONTRIBUTORS

Nancy Bellantoni

Born to artist parents, Nancy almost inevitably became an artist herself. She received her design training at the Boston agency Gunn Associates and went on to found Movidea Inc. with her husband, Peter Galipault. There she has conceived, developed, and coordinated branding and marketing solutions for countless clients, from startups to Fortune 500 corporations. Nancy holds an MBA from Simmons University and an MA from the Ohio State University. A lover of the arts, especially modern dance, Nancy is also an avid blue-water sailor. She has a USCG 100-ton Near Coastal Masters license and teaches yoga in Boston. This is her first book.

Janice Blake

Janice fell in love with the art and craft of writing at age eight. As a young woman, she launched her writing career at Polaroid Corporation, in a marketing organization that was legendary at the time. For more than three decades she worked as a freelance copywriter and editor in the Boston area. She edited books for Harvard Business School Press and the Brazelton Institute at Boston Children's Hospital, and taught writing workshops at Harvard Business School. In recent years, she has been researching and writing about World War II. Janice and her husband live in Southern California.

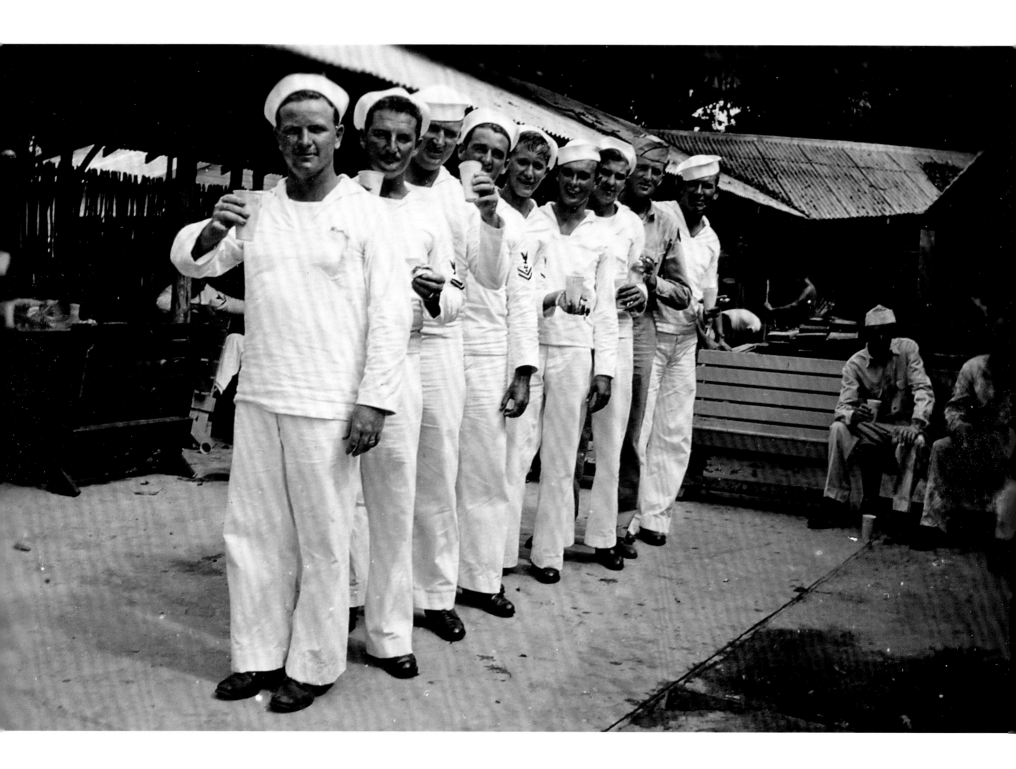

ACKNOWLEDGMENTS

———

Many individuals contributed to the creation, design, and production of *The Battalion Artist*. Special thanks go to all the members of Hoover Press (Barbara Arellano, Marshall Blanchard, Jennifer Navarrette, Scott Harrison, John O'Rourke, Darrell Birton, Laura Forbes Somers, and Alison Throckmorton Petersen), who oversaw the publication process with tireless work, dedication, humor, and expertise. The Hoover Archives preservation and digital imaging teams provided amazing conservation and imaging efforts for the Natale Bellantoni collection. Digital imaging specialist Fiore Irving—whose work with the Bambi mascot sketch is a marvel!—put in countless hours producing the high-quality images featured in this book. Archivists Lisa Nguyen and Julia Hickey, who oversee the Hoover digital lab, helpfully and patiently organized the workflow of imaging, keeping us all ahead (or at least aware!) of deadlines. Diana Sykes, whose speed in delivering images is unrivaled, also proved her genius for color correcting posters. Our success with this project also relied heavily on Stephanie Watson and her skilled team of accessioning archivists, who organized the Natale Bellantoni collection upon its arrival at Hoover and provided space wherein the editorial team could explore its richness and select items for publication. To all of our amazing staff, thank you for making time for this project and sharing your incredible arsenal of expertise.

Finally, we would like to thank our director, Eric Wakin, for supporting this project, and Nancy Bellantoni and Janice Blake, who offered not only their fascinating text and design advice but also their personal knowledge of Nat's life and career. We are proud to add his collection to the holdings at Hoover Library & Archives, and to have this publication to celebrate Nat's talent and spirit.

Jean M. Cannon
Curator for North American Collections
Hoover Library & Archives, Stanford University

ADDITIONAL RESOURCES

Further Reading

Members of the 78th Construction Battalion]. *Battalion Log Seventy-Eighth U.S. Naval Construction Battalion.* [Place of publication and date (sometime in 1945) unknown.]

Building the Navy's Bases in World War II: History of the Bureau of Yards and Docks and the Civil Engineer Corps 1940–1946. Volume II. 1947. Washington: United States Government Printing Office. "Bases in the south Pacific: Noumea" pp. 221–28; "Bases in the Southwest Pacific" pp. 278–79; "Chapter 30: Okinawa," pp. 397–412; "Appendix: Seabee Record," p. 419.

Castillo, Edmund. *The Seabees of World War II.* New York: Binghamus, 1963.

Huie, William Bradford. *Can Do! The Story of the Seabees.* Annapolis: Bluejacket Books, 1997

Huie, William Bradford. *From Omaha to Okinawa: The Story of the Seabees.* Annapolis: Bluejacket Books, 1999

Messenger, Charles. *The Chronological Atlas of World War Two,* New York: Macmillan, 1989.

Miller, Donald L. *The Story of World War II.* New York: Simon & Schuster, 2001.

Miller, Nathan. *War at Sea: A Naval History of World War II.* New York: Scribners, 1995.

Millet, Jeffrey R. *U.S. Navy Seabees: The First 50 Years 1942–1992.* Dallas: Taylor Publishing Company, 1993.

Nichols, Gina. *The Seabees at Gulfport.* San Francisco: Arcadia, 2007.

Nichols, Gina. *The Seabees at Port Hueneme.* San Francisco: Arcadia, 2006.

Spector, Ronald H. *Eagle Against the Sun: The American War with Japan.* New York: The Free Press, 1985.

Steinberg, Rafael, and the Editors of Time-Life Books. *Island Fighting.* Chicago: Time-Life Books, Inc., 1978.

Symonds, Craig L. *World War II at Sea: A Global History.* Oxford: OUP, 2018.

Van der Vat. *The Pacific Campaign: The U.S.-Japanese Naval War 1941–45.* New York: Simon & Schuster Paperbacks, 1991.

Weinberg, Gerhard L. *A World at Arms: A Global History of World War II.* New York: Cambridge University Press, 2005.

Wheeler, Keith, and the Editors of Time-Life Books. *The Road to Tokyo.* Chicago: Time-Life Books, Inc., 1979.

Online Source

See author Janice Blake's website dedicated to *The Battalion Artist*: http://janiceblake.com/books/book/the-battalion-artist

Museums and Archival Repositories

Camp Gordon Johnston WWII Museum
1873 Highway 98 West
Carrabelle, FL 32322
www.campgordonjohnston.com

Camp Shanks WWII Museum
20 Greenbush Road
Orangeburg, NY 10962
www.orangetown.com/document/camp-shanks-museum

Eldred World War II Museum
201 Main Street
P.O. Box 273
Eldred, PA 16731
eldredpawwiimuseum.com

Hampton Roads Naval Museum
1 Waterside Drive
Norfolk, VA 23510
www.history.navy.mil/content/history/museums/hrnm.html

The International Museum of World War II
8 Mercer Road
Natick, MA 01760
www.museumofworldwarii.org

Keirn Family WWII Museum
160 St. Mary Street
Loretto, PA 15940
www.francis.edu/Keirn-Family-World-War-II-Museum

The National Museum of the American Sailor
2531 Sheridan Road
Great Lakes, IL 60088
www.history.navy.mil/content/history/museums/nmas.html

The National Museum of the Pacific War
340 East Main Street
Fredericksburg, TX 78624
www.pacificwarmuseum.org

The National Museum of WWII Aviation
755 Aviation Way
Colorado Springs, CO 80916
www.worldwariiaviation.org

The National Museum of the US Navy
736 Sicard Street SE
Washington, DC 20374
www.history.navy.mil/content/history/museums/nmusn.html

The National Naval Aviation Museum
1750 Radford Boulevard
NAS Pensacola, FL 32508
www.navalaviationmuseum.org

The National WASP WWII Museum
210 Avenger Field Road
Sweetwater, TX 79556
www.waspmuseum.org

The National World War II Museum
945 Magazine Street
New Orleans, LA 70130
www.nationalww2museum.org

The Naval War College Museum
Luce Avenue
Newport, RI 02841
www.usnwc.edu/NWC-Museum

Palm Springs Air Museum
745 North Gene Autry Trail
Palm Springs, CA 92262
www.palmspringsairmuseum.org

The Pearl Harbor Aviation Museum
Hangar 37, Ford Island
319 Lexington Boulevard
Honolulu, HI 96818
www.pearlharboraviationmuseum.org

Puget Sound Navy Museum
251 1st Street
Bremerton, WA 98337
www.pugetsoundnavymuseum.org

Rosie the Riveter WWII Home Front National Historic Park
1414 Harbour Way South, Suite 3000
Richmond, CA 94804
www.nps.gov/rori/index.htm

The US Naval Academy Museum
118 Maryland Avenue
Annapolis, MD 21402
www.usna.edu/Museum

The US Navy Seabee Museum
3201 N. Ventura Road
Naval Base Ventura County PH, Building 100
Port Hueneme, CA 93043
www.history.navy.mil/content/history/museums/seabee

USS Cassin Young National Historic Park
Charlestown Navy Yard
Boston, MA 02129
www.nps.gov/bost/learn/historyculture/usscassinyoung

The WWII Home Front Museum
4201 1st Street
St. Simons, GA 31522
www.coastalgeorgiahistory.org/visit/world-war-ii-museum

Wright Museum of World War II
77 Center Street
Wolfeboro, NH 03894
www.wrightmuseum.org

3.

M. Bellantoni
U.S.N.C.B

FEATURED ARTWORK

Page 107
Photograph of Natale Bellantoni in uniform
Natale Bellantoni Papers, Box 3

Page 108
Natale Bellantoni in a postwar art studio
From the private collection of Nancy Bellantoni

Page 110
A hand-drawn map of Bolo Point, Okinawa, September 1945
Natale Bellantoni Papers, Box 1

Page 112
Photograph of sailors toasting their glasses
Natale Bellantoni Papers, Box 3

Page 117
Detail from Natale Bellantoni's sketchbooks
Natale Bellantoni Papers, Box 1

Pages 124–125
Sketch of boat and sailors
Natale Bellantoni Papers, Box 8

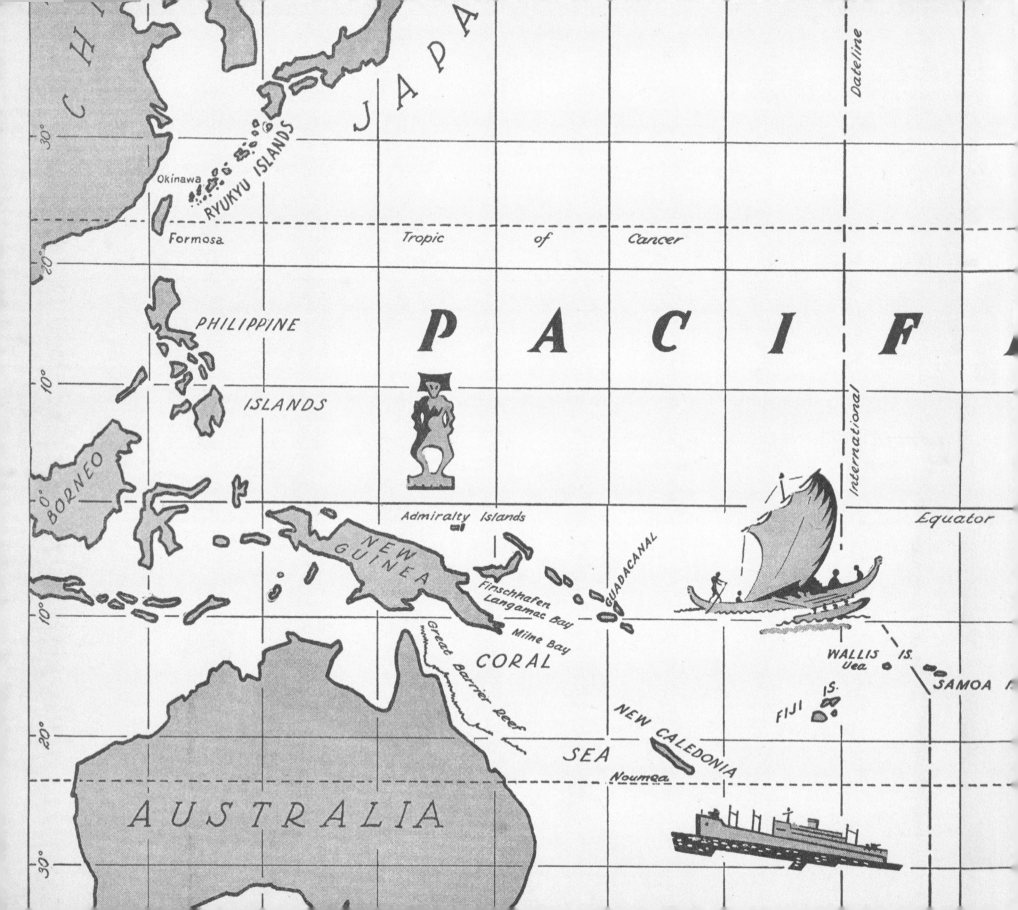